MIXED MANIA

RECIPES FOR DELICIOUS MIXED-MEDIA CREATIONS

DEBBI CRANE & CHERYL PRATER

INTERWEAVE.
interweavebooks.com

PHOTOGRAPHY annette slade
INTERIOR & COVER DESIGN karla baker
PHOTO STYLING pam chavez
TECHNIQUE PHOTOGRAPHY ann swanson

Interweave Press LLC
201 East Fourth Street
Loveland, CO 80537-5655 USA
interweavebooks.com

Printed in China by Asia Pacific Offset

Library of Congress Cataloging-in-Publication
Data

Crane, Debbi
 Mixed mania : recipes for delicious mixed media
creations / Debbi Crane,
Cheryl Prater, authors.
 p. cm.
 Includes bibliographical references and index.
 ISBN 978-1-59668-084-5 (pbk. : alk. paper) 1.
Handicraft. I. Prater,
Cheryl, 1967- II. Title.
 TT157.C7133 2008
 745.5--dc22
 2008010525

10 9 8 7 6 5 4 3 2 1

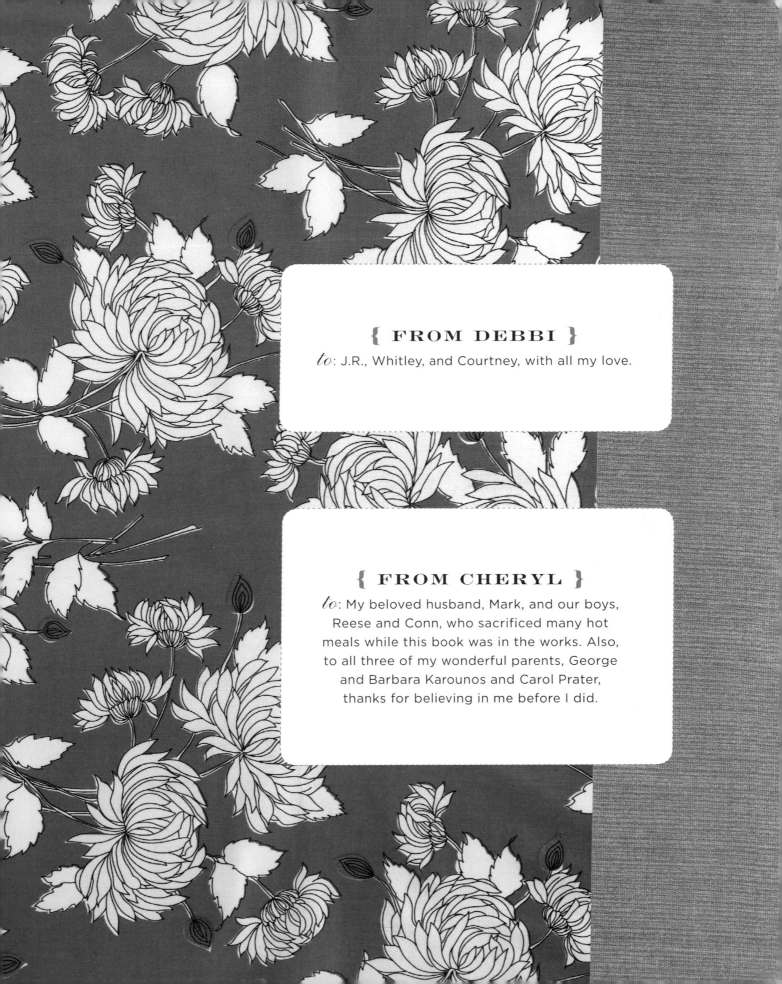

{ FROM DEBBI }

to: J.R., Whitley, and Courtney, with all my love.

{ FROM CHERYL }

to: My beloved husband, Mark, and our boys, Reese and Conn, who sacrificed many hot meals while this book was in the works. Also, to all three of my wonderful parents, George and Barbara Karounos and Carol Prater, thanks for believing in me before I did.

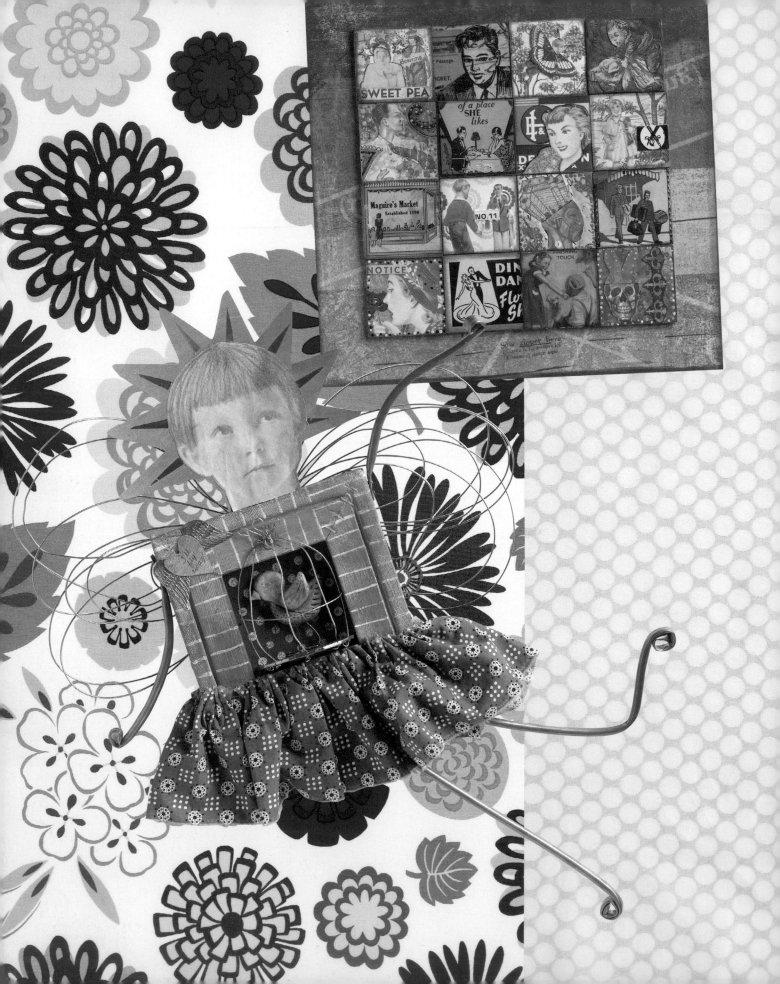

TABLE OF CONTENTS

TABLE OF CONTENTS

From: Cheryl Prater
Sent: Monday, December 10, 2006 6:45 PM
To: Debbi Crane
Subject: Six Degrees of Kevin Bacon

Hi Debbi:

I have been meaning to e-mail you for over a month. Cate Prato at *Cloth Paper Scissors* gave me your e-mail, so it's her fault that I'm bugging ya. My name is Cheryl Prater, and you and I are actually less than six degrees apart. We're like two degrees apart because I know—in a cyber-sense—Patricia Bolton and Cate Coulacos Prato at *Cloth Paper Scissors*. We're practically family. AND we share the auspicious honor of both being *CPS* cover girls. I am Miss January/February 2007! Do you lead a support group for incredulous cover artists? If so, please send me meeting times and start me on the 12-step program!

Hope to hear from you soon.
Best,
CP

ps: I am also a flat-lander, originally. From Chicago . . . now in Atlanta.

From: Debbi Crane
Sent: Tuesday, December 12, 2006 2:14 PM
To: Cheryl Prater
Subject: Re: Six Degrees of Kevin Bacon

When I read the subject line, I almost deleted your message because I have been getting a TON of stock-trading spam with similar subject lines.

CONGRATS on your cover. It IS a big deal and you ARE the poo! My girls, 13 and 14, and I have this thing that we do with "my" *CPS* covers. When we see it in a store, we move it to the front or top of the rack, switching it with, say, *Knit World* or something. In Barnes and Noble, we just spread a few copies right across the eye-level row on the mag rack. Have fun with being on the cover. I try to act like it's nothing special, but, really, I just want to run screaming thru town that I AM ON THE COVER OF A MAGAZINE!

There is no 12-step program. Just keep a copy with you at all times, and tell everybody.

peace, love, and paper,

Debbi

D: I am so happy we decided to publish our first e-mail exchange.

C: Because it shows that we met online and yet are dear friends, coauthors, and confidantes?

D: No, because it proves that we met online and NOT on eHarmony, as you like to tell people. Our husbands have always known the truth and, now, so will the world.

C: The truth is, we are an unlikely pair. People, would you believe that we have only met in person twice? We first met in Chicago, April 2007. We were both teaching at the Quilt Festival. I was a little nervous, not terribly unlike a mail-order bride. But as soon as I met Debbi, I was totally at ease. It was like we'd been friends since fifth grade. And even before we'd MIRL (met in real life), we had planned to go to sleep-away art camp together for a week!

D: No. I told you I was going to Arrowmont that week and you registered for the same class, thereby inviting yourself. While at Arrowmont, we had planned to work on a book proposal, but we were too busy making prints to do that!

C: We managed to do something more important instead: We got to know each other. We collaborated. We toiled in the studio into the wee hours. We talked and talked and talked. Even Debbi got a word in here and there.

D: We learned that we are bound by our birth year, our motherhood, our marriages, our faith, and our creativity. But as much as we have in common, we are still very different. But we learned how to work together and appreciate our differences.

C: Despite our diverse approaches to creating, geographic distance, and differing viewpoints, we have formed an unholy alliance, er, unlikely friendship, and *Mixed Mania* is the result.

D: Cheryl and I definitely do things differently, and you probably have your own way, too. This would be a boring book if we were the same.

C: So, dig in! We'd hate for your next creative meal to get cold. Ironically, while Debbi and I were working on this "cookbooky" book, both of our families lived on Golden Grahams and Pizza Hut. Make their sacrifice worth it! Bon appétit!

HOW TO USE THIS BOOK

We love this quote by celebrity chef Thomas Keller: "A cookbook must have recipes, but it shouldn't be a blueprint. It should be more inspirational; it should be a guide." Anyone can follow a recipe; it's the truly great cooks who add their own flavor.

The instructions we've provided detail how we created the projects seen here. But just as you might alter a recipe, we encourage you to improvise with different materials, themes, and colors than the ones we chose or try the project components à la carte. Play with the processes by adding your own signature spices and seasonings to suit your unique tastes. Add a pinch of glitter, substitute pastels for paint, or omit an ingredient altogether —the result will be a flavor that is uniquely your own. The only mistake you can make is to not make anything at all.

THE WELL-STOCKED PANTRY

Just as you need certain staple ingredients and basic tools in your kitchen, your studio pantry should not be without these basics. This section will cover materials any mixed-media artist, aspiring or seasoned, needs to have on hand. For those just dipping their toes into the mixed-media pool, here you will find the basic materials and tools. For those who know their way around a self-healing cutting mat, you may find alternatives to common materials and tools that we use and like. No pantry would be complete without some tried-and-true recipes for composition.

{ TOOLS }

bone folder Use one of these for making sharp creases in paper. Natural and synthetic models are available in most art-supply stores.

bookbinding awl This is a sharp tool for making holes in lots of things, but primarily the pages of books you are binding by hand.

craft knife, blades Reach for these when making precise cuts; change your blade frequently, and use caution when disposing of dull blades.

cutting mat A variety of sizes will be useful. You'll want to have one that's larger than 12" x 12" (31 x 31 cm) to accommodate larger papers.

handsewing needles, assorted sizes We like to stitch . . . lots. But embroidery needles are especially useful for bookbinding.

heat gun This is a necessity for all impatient crafters and artists! It speeds up dry times and sets embossing powders.

hole punch You don't need anything fancy, just the kind you can buy for a buck at the dollar store.

Japanese paper drill If you plan to do a lot of book-binding, this is worth the investment. Your paper drill will enjoy a long life if you take good care to only use it on a soft surface, such as your cutting mat. You can buy different sized tips for your drill, too.

metal ruler Metal rulers are preferred over wooden or plastic rulers because you won't cut them with your knife.

paintbrushes Purchase lots of sizes and qualities. The Land of Mixed Media probably isn't the best home for those $20 brushes, though, because you never know what materials you may find yourself using. Sponge brushes are great because you won't feel as guilty wrecking them and throwing them away.

paper punches Consider purchasing a set that has a variety of sizes and geometric shapes.

scanner/printer Scanning and then printing is a great way to use favorite sketches and images multiple times. These tools also are good for resizing images. We could write a whole 'nother book on just scanners and printers and ways to use them. Keep extra ink on hand. There's nothing more frustrating than trying to print your valentines at 11:00 p.m. on February 13 and running out of ink.

sewing machine A simple one with a straight stitch will be all you need to complete the sewing projects in this book.

small sharp scissors Cutter Bee scissors by EK Success are our favorite. They are great for silhouette cutting and closely trimming around collage images.

stylus Use for dipping in paint and dotting on "paint pearls."

acrylic gel medium This item will appear repeatedly on the ingredients lists in this book because it's the No. 1 way to add texture. We've tried lots of kinds; Golden is our favorite.

acrylic paint Experiment with artist-quality paints and craft-quality paints to see what works best for you. When we're feeling particularly sassy, we'll use a combination of both . . . in the same project!

Bazzill chips These are the building blocks of many a *Mixed Mania* project because the little 1½" (4 x 4 cm) square staples are great modular mini-canvases.

canvases Hit an art-supply sale and grab some in a variety of sizes and profiles.

cardstock Bazzill Basics textured cardstock comes in a huge array of saturated colors. The line also features the subtlest bit of texture.

colored pencils Higher quality pencils yield better results. Ticonderoga or Prismacolor are both excellent brands.

Diamond Glaze This glaze, by JudiKins, is handy stuff. You can use it as clear-drying adhesive, clear lacquer, or as clear dimensional medium. It securely holds vellum, acetate sheets such as Embossable Window Plastic, glass beads, glitter, and many other media. You can mix it with dye-based inks, watercolor paints, pearlescent pigments, and more. Love it.

E6000 heavy-duty adhesive In mixed media, really, anything goes, so you will want to have an industrial-strength adhesive for applying dimensional items, such as flat marbles or metal. This brand is a rubber-based compound with sealant qualities.

embroidery floss and sewing thread They are cheap. Keep lots of your favorite colors around.

fat quarters These inexpensive (especially when on sale or if you have a coupon) quilting scraps are great to keep around for when the mood to fire up the sewing machine strikes. Buy colors and patterns you love. You'll use them.

found objects and ephemera Don't throw away that burned-out taillight bulb; you might find a use for it. Junk sales? If it's cheap, and you like it, buy it. You don't need to know what you're going to do with it yet; just keep it around and see what happens. Some examples of junk rattling around Cheryl's studio are old keys, hinges and hardware, wooden spools, antique matchbooks, vintage patterns, tintypes, bread tins, postcards, cigar molds, engraved offset printing plates, doll parts, spice tins, and toy cars.

freezer paper/palette paper Both can be used to stabilize fabric to run through your printer. Just iron muslin onto the poly-coated side. Palette paper is great because it's already cut and flat and only requires a quick trim to size it for your printer.

glue stick Nothing fancy here. We like untinted UHU.

Grumbacher opaque watercolors Get them in the tray. They are bright, deep, long-lasting colors.

iron-on transfer paper These sheets are intended for t-shirts, but we use them in many of our projects.

mini-cupcake papers These make great little disposable pots for mixing paint. They are also good for collecting embossing powder that you are shaking off an object, facilitating pouring the excess back into the jar.

muslin Keep a yard or two of bleached and un-bleached on hand. Wash, dry, and press as soon as you get it home, so it will be ready when you need it.

patterned papers Stock up. Paper doesn't spoil. We especially like BasicGrey.

Tacky Glue Within your adhesive stash, you need the Aqua Net of glue by Aleene's, which, when applied, has a good, thick hold. We're talking white craft glue. Use sparingly around just the edges of paper you are gluing into collage.

textures Get creative when thinking about stuff to press into gel medium and paint—bubble wrap, Wholey Paper by Random Arts, mesh netting from fruit, sequin design scrap.

water-soluble crayons Caran d'Ache are the best. There are other brands, but none can compare with the Swiss's colors, blend-ability, and ease of use. Go Swiss or go home.

waxed-linen thread Four-ply from Royalwood is our fave for bookbinding and other uses. It is stronger than thread or embroidery floss and available in many colors.

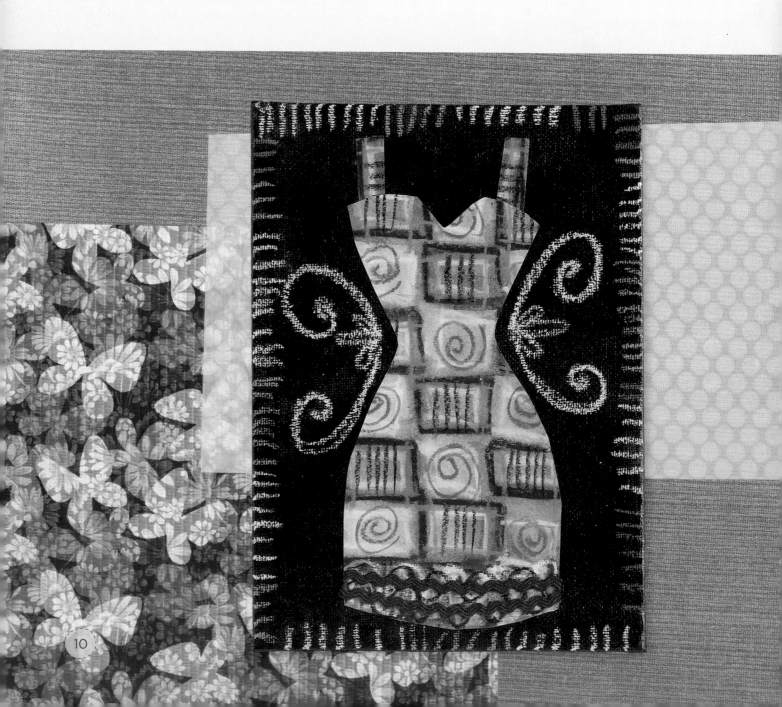

SUBSTITUTION CHART

Whether in the kitchen or in the studio, we have all been there: You are waist deep into your recipe and you run out of a key ingredient. The outcome of this situation can be disastrous or successful. To achieve the latter, you just need a little "Hey, I can use this instead!" ingenuity.

air-dry craft clay Make a simple salt dough. Use one cup of salt, one cup of flour, and enough water to make a stiff dough.

antiquing medium Watered-down, brown acrylic paint will work in a heartbeat. You want the diluted paint to have the consistency of milk. Brush on and wipe off with a paper towel. Allow to dry and add additional coats to darken.

bone folder A butter knife can be used in place of a bone folder for creasing and scoring paper.

water-soluble crayons Borrow a kids' crayons to use in place of Caran d'Ache or oil pastels. Regular crayons are not water-soluble, but they can be used to create colorful, scribbly marks around the edges of collage elements and pages in your handmade books, artist trading cards, and paintings. You can also draw with them on white paper and watercolor over the top.

collage sheets If you don't have any of those beautiful glossy collage sheets full of images and patterns, grab your stacks of magazines and catalogs. Sift through for patterns and textures that you can cut into interesting shapes to use in your artwork. My favorite is the Anthropologie catalog.

compass You can use cups, bowls, plates, and glasses in place of a compass to draw perfect circles in a variety of sizes.

Diamond Glaze Head to the tool box, the garage, or the shed and grab two-part epoxy resin; it creates the same effect as dimensional glaze (e.g., Diamond Glaze by JudiKins) for filling in bottle caps, charms, and niches.

finishing glaze Shoe polish can be used as a finishing glaze on collages. Use brown to tone down or age the artwork, clear to add a little shine. Use a soft cloth to rub in a small amount of polish and buff off. Shoe polish is oil-based, so it should be the last step.

gel medium If you don't have gel medium, can't afford it, or can't wait to have it shipped to your house (hello, Cheryl!), mix two parts white craft glue with one part water. Use it under and over collage elements to adhere and seal. This mixture keeps well in a covered container.

paint palette A plastic or styrofoam egg carton makes a perfect disposable palette. The small compartments will keep you from mixing too much of a weird color.

texture stamps These stamps are wonderful for applying background texture to your pieces, but they can be expensive. A cheaper alternative with lots of "sole" is your shoe. Use a damp cloth to clean off your rubber soles. Allow to dry and dab with an inkpad. Stamp for a unique background texture. Make sure to clean off the ink before wearing again to make sure you don't leave footprints all over your carpet.

CREATIVE KITCHEN BASICS

Not all great chefs go to culinary school, and you certainly don't need a degree in art to create beautiful, meaningful pieces. But a little art instruction couldn't hurt. The elements of art and the principles of design will help you figure out what to add or subtract to make your art taste just right.

{ THE ELEMENTS OF ART }

These are the building blocks, your foundation. Everything you make contains most of these elements, so learn to recognize how they work independently of each other inside a unified whole.

line Within your artwork, the lines convey mood. Experiment with adding delicate curvy lines or bold scribbled lines to your artwork, and notice how the feeling of the piece changes.

color Choose colors to go along with the story you are telling in your work. Crayon brights lend a playful tone to your work, while muted shades give a somber feeling.

shape and form Shapes are flat. Forms are their three-dimensional counterparts. Shape and form come in two varieties: geometric and organic. Geometric shapes and forms are always the same and follow a regular formula, while organic shapes and forms are found in nature and are always different. Geometric shapes and forms are useful in artwork that you want to be orderly and quiet; wild organics are free and noisy.

texture Texture adds tactile or visual interest to flat, unbroken planes of solid color. When working in fabric, try placing different textures next to each other, such as a satin with a tweed. Use gel medium to apply a layer of wadded tissue paper on a blank canvas and allow it to dry before adding your first layer of paint.

value This is the range of light and darks within your artwork. Visually, dark values tend to recede into the background and light values advance.

space When you consider space in your artwork, you are looking at depth perception. Instead of lining up the elements of a collage or painting in a straight row or grid, overlap elements to make some parts seem farther away than others.

The principles of design are ways to apply the elements of art. Understanding these principles will help you take control of your artwork.

rhythm Rhythm will make a composition dance; it is most often achieved through repetition of elements. Use a pattern or repeat a motif to break up big chunks of blandness. You can scatter motifs in a random fashion, like sprinkles on a cupcake, or space them evenly like cookie dough on a baking sheet. Use a ruler if you need to for a more uniform approach.

balance There are three types of balance: symmetrical, asymmetrical, and radial. When a piece has symmetrical balance, the parts are roughly the same on each side of a central axis. If you choose asymmetrical balance, the parts do not match exactly from side to side, but the overall composition is still interesting through a call-and-response style of arranging things. In radial balance, there is a defined center point, and the elements radiate out from the center.

variety and unity Different, but the same. Choose a pattern, such as polka dots, to repeat throughout a project; this is unity. Use lots and lots of different colors and sizes of those polka dots; this is variety.

emphasis Most compositions will benefit from some sort of visual hierarchy. This starts with a focal point—what you want the viewer to see first—and continues with ancillary elements to support it.

proportion Proportion is the size relationship between the parts and the whole piece. When you are drawing, intentionally changing proportions of faces, figures, and common icons is a great way to give your drawings a shot of individuality and fun.

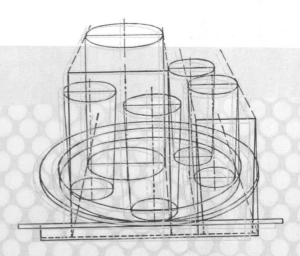

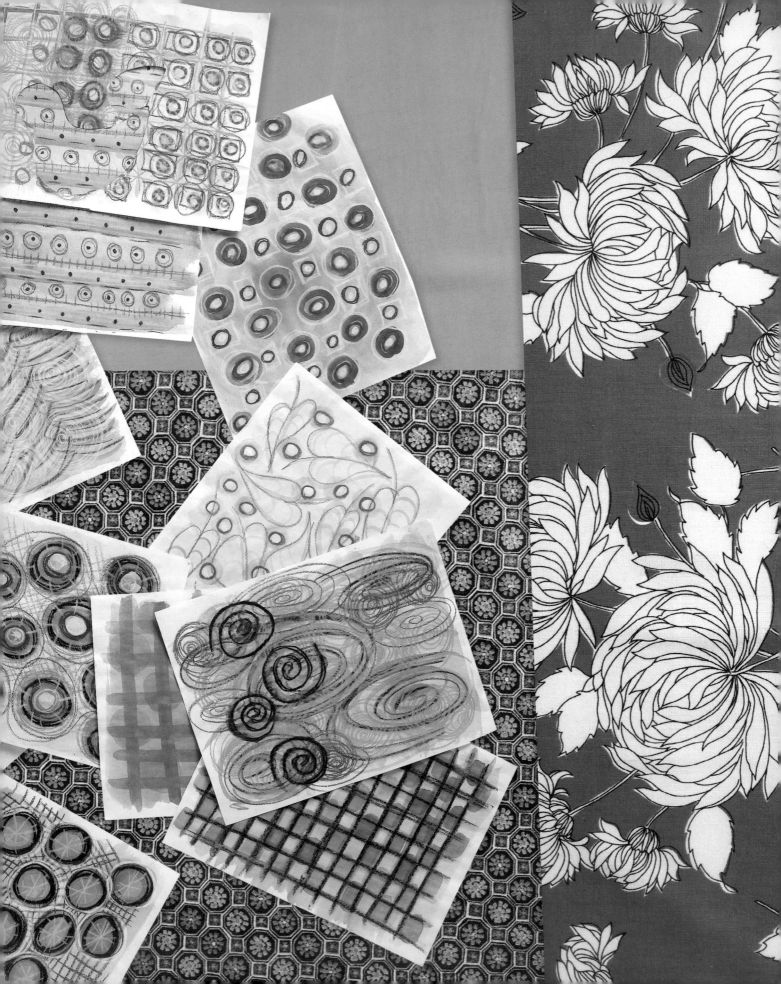

ARTISTIC APPETIZERS

C: Debbi, do you remember that night at Arrowmont when we sat up and looked at Patricia Bolton's book, *1,000 Artist Trading Cards*?

D: I've tried to forget, but can't. You grilled me for three hours!

C: It was uncanny! I would tell you which ATCs I liked, and then you would tell me why I liked them. You totally defined my aesthetic, and this was only the second time we had met in person. How did you do that?

D: I don't know. I guess I just know what I like and why I like things, and it's easy for me to connect those dots for other people as well.

C: I thought it was pretty amazing because it was like you knew me better than I knew myself.

D: I wouldn't say that, but I have considered myself an artist for a much longer time than you have.

C: Wait, whoa, artist? I never said I was an artist. I just make stuff.

D: You are absolutely an artist, but perhaps a little shy in admitting to it because it is early in your journey. As you progress, you will begin to understand the whys behind what you like and what you don't like. I think a lot of artists out there feel just like you do, overwhelmed by their own creativity. This chapter was made just for them.

C: Absolutely. Our mixed-media appetizers are little nibbles of art that will give newbie media mixers the encouragement to create no matter how busy they think they are. In 100 years, nobody is going to know or care if your toilet was clean, but something you wrote or created might still be around. By the time Jane Austen was my age she was dead.

D: Wow, Cheryl, how old are you?

C: The same age as you. The goal of these projects is to remove the intimidation factor by taking small bites. They are easy enough to complete in a short amount of time with inexpensive, basic materials. They also will prime your "palette" for the Main Courses in Chapter 2.

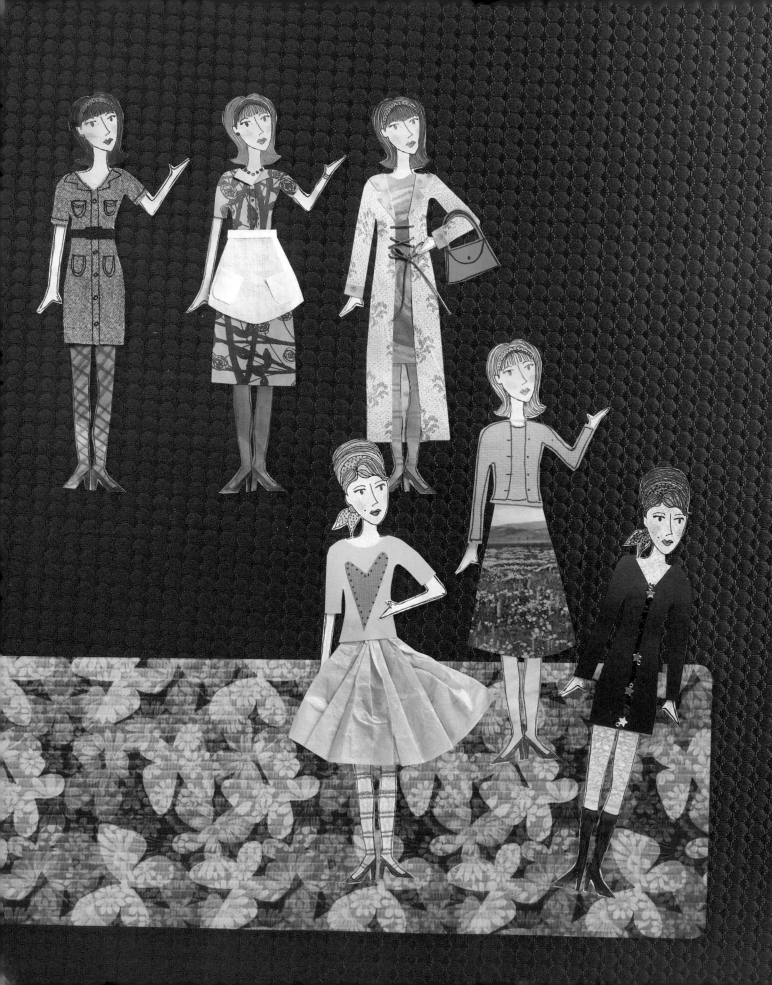

DEBBI's PAPER DOLLS

{ BETCHA CAN'T MAKE JUST ONE! }

> "HOW MANY CARES ONE LOSES WHEN ONE DECIDES NOT TO BE SOMETHING BUT TO BE SOMEONE."
>
> —COCO CHANEL

I LOVED PAPER DOLLS AS A CHILD.

Makes sense, as they were paper, after all, and I have been forever drawing, cutting, and gluing paper. I had several of those large, glossy books of Barbie paper dolls, with the perforated-edge clothes that were supposed to stay on paper Barbie with those tiny little tabs. But they never did.

I suppose that I have never really outgrown my paper dolls. Since 2004, I have given myself a daily art assignment. In 2005, I worked every day in a big fat art journal. As the year drew to a close and I needed another assignment for 2006, I looked back through my journal and realized how many entries contained a cut-and-glue figure of some kind: in fact, a paper doll. On an impulse, as usual, I challenged myself to make a different paper doll every day for 2006.

I was successful in completing my paper-doll challenge, and it is my favorite daily-art challenge to date. Perhaps it was because it brought me back to my childhood, allowing me to have playtime once again. Or because I had fun making so many alter egos. I know the practical gal in me loved that I could make these small and simple creatures only to reuse them in a variety of other projects (see project on page 70 to see how I transferred one of the doll images onto a fabric journal cover). And I totally love the mid-century modern flair of the doll.

For you, paper dolls could be a wonderful place to begin your mixed-media experience. Getting dressed is something that we, most of us at least, do every day. Inspiration is no further than your favorite fashion magazine. Plus, these sassy, simple creations require little to no drawing, meaning you can jump right into the fun.

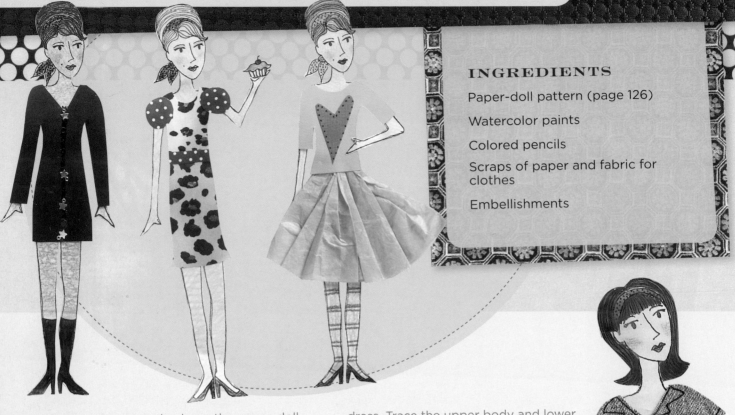

INGREDIENTS

Paper-doll pattern (page 126)

Watercolor paints

Colored pencils

Scraps of paper and fabric for clothes

Embellishments

1 Photocopy and enlarge the paper-doll pattern on page 126. Print onto card-stock. Color the skin. Watercolor paints work well, but you can use pencils, crayons, or even leave it blank.

2 Allow the skin to dry, if necessary, and add color to the hair. It doesn't have to be "natural" or even come from Mother Nature's crayon box.

3 Use a colored pencil to gingerly add lipstick and blush.

4 Cut out the doll. Alter her head and arms if you like—use small photos of your friends' faces (these make great favors or place cards for your next get-together—adorable for a bridal shower or birthday party).

5 Dress her! To make a basic dress, place the doll face down on the wrong side of a piece of paper or fabric. Trace around her arms and body. Cut out the

dress. Trace the upper body and lower body individually to make a set of separates: a skirt or pants and a top.

6 Give her some pizzazz. You can alter the clothing in many ways: plunge the neckline and inch up that hemline, or make the skirt fuller or straighter. You can also shorten or lengthen the sleeves.

7 Don't forget to color her shoes and consider giving her some tights. Go sleek and sophisticated or go wild with a pair of shiny red knee-high boots.

8 Use your tiny scraps you can't bear to throw away for belts, hats, and purses. Design outrageous outfits you would never wear in real life!

9 Use cardstock to make a stand for your doll.

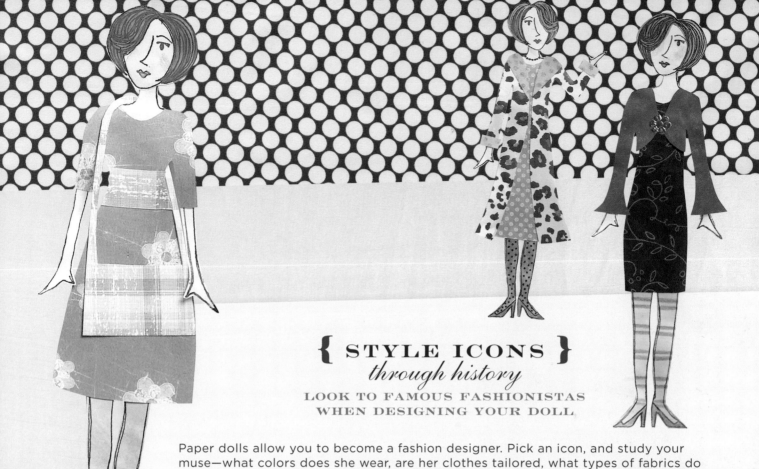

{ STYLE ICONS }
through history
LOOK TO FAMOUS FASHIONISTAS
WHEN DESIGNING YOUR DOLL

Paper dolls allow you to become a fashion designer. Pick an icon, and study your muse—what colors does she wear, are her clothes tailored, what types of fabrics do you most often see on her, is her jewelry understated or flamboyant? Now, apply these characteristics to your dolly.

MARIE ANTOINETTE Corsets and crinoline, of course, so anything with an accentuated waist and bosom that will flatter the female silhouette will work for your doll. It could be argued that this was the beginning of couture, so clothing should be created from rich, opulent fabrics in royal and intense shades. Detailing would be very important as well; consider emphasizing the neckline and the curvature of the waist. Use sleeves with pearl buttons that draw attention to long, sinewy arms as well as skirts with bustles. Powdered skin and hair in an up do. Don't forget the beauty mark.

JACQUELINE KENNEDY ONASSIS She is demure, she is exquisite, she is grace. If you start from the top down, go for a bouffant hairdo with flipped ends topped off with a pillbox hat. Her trademark look was a tailored Chanel suit, simple coat, and white gloves. Her dresses featured round or bateau necklines and slim-fitted A-line skirts. And remember the huge, bug-eyed black plastic sunglasses. Her favorite designer was Oleg Cassini, for those who want to research her look more deeply.

MADONNA Wow, pick an era for Madonna. She is queen of the dance floor and has rocked the 1980s, the 1990s, and the millennium. When she first hit the scene, her hair was wildly teased and multicolored. Finding a forearm under all those bracelets was tough. She was excellent at mixing lace with denim, leather, and mesh. Fishnet stockings, beads, and a rosary also were part of her signature look. She easily camouflaged that look behind the material girl, who was equal parts Marilyn Monroe and total pop queen. We've also seen her evolve from a fashion fetishist to the hipper, sleeker Material Mom look that she sports today.

CHERYL's DOODLES
{ CANDY IS DANDY, BUT DOODLES ARE LESS FATTENING }

"DON'T AGONIZE. IT SLOWS YOU DOWN."
—ISAAC ASIMOV

DOODLE.
THE WORD ITSELF IS SO SILLY.

Why is it so intimidating? I know what you are thinking: you are going to skip this exercise because you think you can't draw. Well, I thought I couldn't draw, and lookie here, I've got a published book that says I can. The rumors of extortion are almost completely unfounded. You can do this.

Doodling is the antithesis of drawing by virtue of that fact it doesn't have to look perfect or have proper proportions, scale, or perspective. The purpose here is to not have a purpose. The goal is intentionally NOT drawing but blissfully, aimlessly doodling without a thought as to whether you're making anything "good." Don't think, don't criticize, just remember what Yoda told young Luke Skywalker: "Do(odle) or do(odle) not . . . there is no try."

And it's not like a doodle needs to be created in permanent ink. These doodles all started out in pencil—how's that for noncommittal? You can keep the ones you like and shred the rest.

Create body parts in simple shapes. That makes it easy to experiment by trying heads on different bodies at different angles. I like to try short legs and long arms, no arms in a dress, big floppy ears, whatever. And if I draw, um, I mean *doodle* a head I really like, I can make sure I doodle a deserving body to go with it and glue them together later.

So tell your inner critic to beat it, grab your pencil and paper, and get your doodle on. Don't give up after one attempt at this exercise. You don't even have to dedicate any "real" time to this exercise—doodle while watching TV or sitting in the orthodontist's waiting room.

how to DOODLE

INGREDIENTS

Pencil

Good eraser, the gummy kind works best

Matte photo paper (it's smooth and of heavier weight)

Fine-point waterproof black marker (i.e., Sharpie)

Caran d'Ache water-soluble crayons or watercolor paints

1 Start out with pencil to an 8½" x 11" (22 x 28 cm) sheet of matte photo paper, and start to doodle. Doodle whatever comes to mind—faces, scribbles, your house. For faces, draw their features first and then draw their heads around them. Draw several, moving on to the next without giving any one drawing too much thought.

2 Make several doodles with both hands; you may be pleasantly surprised at what results from your non-dominant hand.

3 Pick out one or two faces you like and ink over the pencil marks with your Sharpie. Allow the ink to dry and erase the pencil marks.

4 Cut out your inked doodles.

5 Repeat steps 2, 3, and 4 for bodies. Try simple shapes with simple limbs (if any).

6 Start arranging heads and bodies together. Play around, see what fits well together.

7 Once you choose a head-and-body combination, use a little glue to attach head and body.

8 Color in with water-soluble crayons (then sweep over with a damp watercolor brush) or watercolor paints.

9 Once you have several little characters, have fun arranging them in different combinations on various backgrounds. Try them on patterned papers, on painted canvas, or in cigar box assemblages.

{ ADD A PINCH OF YOU! }

GIVE YOUR ARTWORK A PERSONAL TOUCH BY INCLUDING YOUR HANDWRITING

I used to love reading books on handwriting analysis. Fascinating what one could learn from lines, loops, and dots. If you believe that stuff, and I do, your script is as individual as your fingerprint. Sadly, handwriting is becoming a lost art. I think that's why paper arts and mixed media have become so popular. It's in response to the techno burnout we're all suffering at our ergonomic keyboards. Let's start a grass-roots movement and all use (gasp!) our own handwriting in our art!

✧ Break free of the oppression of your Ctrl key, and don't cut-and-paste or print that text!

✧ Resist the urge to rubber-stamp that word!

✧ Don't cut that quote from some preprinted text—WRITE it in your own unique hand!

✧ Down with perfect fonts; serifs be darned!

What you are creating isn't truly personal until you seal the deal. Initial it. Sign it. Draw a doo-hickey on it. Lay it out there on the proverbial line, baby. Don't like your handwriting? So what? It's yours, and that's enough. Don't get hung up on wanting it to look perfect and miss the opportunity to truly impart yourself to your work. Not convinced to join the revolution? Well, then I'll share with you the sage advice Debbi gave me: "Just put the stinkin' mark on the paper."

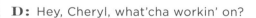

{ TWO COOKS IN THE KITCHEN }
ABOUT THE CREATIVE PROCESS

D: Hey, Cheryl, what'cha workin' on?

C: I don't know yet. How about you?

D: I'm looking for my protractor.

C: Your what?

D: I need to get this angle right.

C: Oh, you must be making some kind of artsy hypotenuse.

D: No, a sketch of something I might make. Haven't decided yet.

C: I don't know why in the world you spend all that time drawing something you MIGHT, MAYBE, EVENTUALLY make. Why don't you just jump in?

D: Because I'm not like you are, crazy and spontaneous and unable to function within a framework. I really enjoy planning every aspect of a project before I touch any materials. Besides, I want to make sure it's right before I waste anything on it.

C: Oh, I see, you mean like wasting TIME drawing up a schematic.

D: No, more like wasting intention. I am a perfectionist, especially when it comes to the message I wish my work to impart. When my finished piece is out there, people will see it and think what they may. I just want them to hear what I am saying.

C: But haven't you ever wanted to succumb to the excitement of just diving down the rabbit hole to see where it leads you?

D: Planning can be very exciting, too, Cheryl. I don't have a lot of time in the studio, so it's like the ultimate challenge in efficiency. If I run into a design problem I can't solve on paper, I leave it alone until the answer is revealed to me. Patience, young grasshopper, is required. And I want to finish what I start, so I must resist the urge to mow through a yard of expensive fabric until I have all the answers. It kills me to waste materials on projects I haven't properly designed.

C: So, you're like the Iron Chef of mixed media?

D: Oooh, I like that! If I am the Iron Chef, who would you be?

C: Private Benjamin—someone who does not thrive on regimen! My creative process isn't really a process. "Process" implies a specific intent, and my only intent is to make something. My way of going about art is more like an anti-process. I don't plan out what I'm going to make or how I'm going to make it. I usually have a general idea of what I want to do, typically inspired by an object I found or an image I like, and I just tear off with no map to follow. The fashion game on pages 96 to 103 was inspired by a similar game I made for my mother-in-law.

It started out as one little embellished photo that I stuck on a checker. It wasn't until I saw it sitting there on my studio table that I was struck with the idea for creating a whole game around it. I couldn't have planned that.

D: I get it.

C: You do?

D: Yeah, it's just like cooking. I use measuring spoons, and you throw in pinches and dashes. I say, "Add x amount of salt." You say, "Add salt to taste."

C: You know, sometimes it's hard for me to understand the way you are wired. One of the biggest creative breakthroughs for me was giving up on perfect. It was so liberating when I finally stopped trying to control every part of the outcome and was free to have happy accidents or make ugly things that taught me something. I don't freak—anymore—if I "mess up" what I'm working on; making mistakes is a great way to learn. Making daily art really helped me in that respect. If I made a square I hated, I'd just shrug it off and know I would make another one the next day.

D: As an artist, my MO is to have an end in mind. I am a bookbinder . . . books are created in series, in editions—the process needs to be repeatable, almost formulaic.

C: I don't think either process is any less fabulous than the other.

D: Agreed. See, Cheryl, having a goal and a plan is not a crime.

C: But if it were, yours would be premeditated and mine would be a crime of passion. You would have killed Miss Scarlet in the studio with a slide rule.

D: So what if I am a Predatory Crafter? I must identify my objective and then capture it. How big will it be? What will I need to create the finished product? What will I do first, second, third? What could go wrong? How will I solve it? I visualize every step, write every instruction, and make outlines of contingency plans in case I wreck something. And, hey, can we stick to the cooking analogies? Measuring cups are infinitely more palatable than chalk outlines.

C: Okay, but for the record, I do have a goal when I sit down to a canvas.

D: You do? What is it?

C: Not blank.

D: Aha!

C: What? You finally come around to my way of thinking? You see the wisdom in my process?

D: No. Found my protractor.

DEBBI's CRAZY PAPERS
{ A GENEROUS HELPING OF YOU }

"WHAT GARLIC IS TO FOOD, INSANITY IS TO ART."
—ANONYMOUS

HELLO.
MY NAME IS DEBBI CRANE,
AND I AM ADDICTED TO PAPER.

I know I'm not alone out there, wandering down the paper aisle of the art-supply store, drooling over the endless variety. As easy as it is to get caught in a budget-breaking paper shopping spree, I find that it's much more creative (and cheaper and fun) to make your own. Plus, making your own paper provides a wonderful opportunity to discover your own palette as well as your design style.

I read a lot of magazines dedicated to mixed media, and lately I am surprised to see many artists using the same brands, even the very same patterns and styles of papers. I don't even like to have the same shoes as someone else, so this makes me a little uncomfortable. In fact, for a while, I forbid myself to use commercially printed papers.

While making this book, Cheryl and I took a printmaking class. Our excellent teacher, Kate Borcherding, taught us loads of techniques for making printed papers using woodblocks, monoprints, etching, and lithography, to name a few. In Kate's class, we used oil-based inks, which are beautiful but a bit messy. As an art teacher for an elementary school, I'm used to water-based, easily-cleaned-up materials.

So, here is the simple, water-based technique for creating printed papers that I devised when I got home from the printmaking class. You can make your own papers, in your own colors, with your own marks, with reckless abandon. You will have a chance to experiment with watercolor and other media that are fast-drying. The materials are cheap enough that you can throw away anything you don't like without so much as a twinge of guilt. As you start creating, you'll see that no two papers are alike. After you feel comfortable creating on inexpensive paper, step it up to heavier weight cardstocks, canvas, and even fabric. Mix your crazy papers with commercially printed papers to add a big dose of "you" to any project.

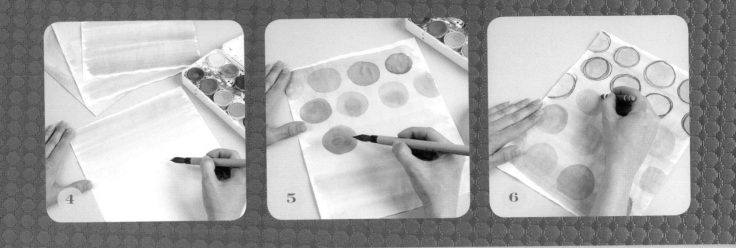

how to CREATE CRAZY PAPERS

INGREDIENTS

10 sheets of 8½" x 11" (22 x 28 cm) white printer paper

Watercolor paints

Caran d'Ache water-soluble crayons

Colored pencils

Assorted brushes

Fixative spray (optional)

1 Begin by dripping a little water onto each of the water-color paints you plan to use. This will soften the paint and result in a more saturated wash of color.

2 Dip a wide brush into the water and then stir over a soft-ened watercolor, coating the brush.

3 Apply a thin, even coat all over one of the 8½" x 11" (22 x 28 cm) sheets, reloading your brush as needed. Keep in mind that painting a wash should never feel like you are scrubbing the floor; be sure to keep your brush wet.

4 Apply a wash to all 10 sheets (see image above).

5 Next, create a large, loose pattern on each of the dry papers (see image above). For this layer, you can get a deeper intensity of color by using less water. Load a brush with a color that contrasts with the wash. Any brush will do, but a sumi brush is great for drawing a variety of lines. You can find a sumi brush at any art supply store. The brushes are used for Japanese brush painting and are quite inexpensive.

6 Doodle a big pattern with the brush (see image above). I like big, imperfect, irregularly spaced circles. I make a circle by placing the brush on the paper and rotating the handle without lifting the bristles. On other sheets, you may choose to draw a variety of lines, making stripes or creating a plaid design. You could use sponges or foam stamps for this step as well. Use the water-soluble cray-ons for the next few layers.

7 Once the watercolor paint has dried, draw another pattern over the top of it. If you don't know what to draw, try outlining the large pattern with a contrasting color, maybe even scribbling over your lines multiple times.

8 After this first pass with the water-soluble crayons, dip a brush into clean water and trace over your lines. The water will cause the lines to bleed and blend into each other.

9 Experiment with layers of multicolored scribbles. You can always experiment on scrap paper to figure out which colors blend nicely and which turn into mud. Remember, it's just a sheet of printer paper; you probably have 300 more in the other room. Give yourself permission to use colors together that might look hideous.

10 After you have drawn and water-painted on all 10 sheets, take a minute to evaluate. Some sheets might look "done" to you at this point.

Other sheets will look like they need something, while others will tell you exactly what they need. Don't spend a lot of time analyzing. Go with your gut reaction. Don't ask others what they think. Simply look at the sheet and react. Trust yourself and make any changes you deem necessary.

11 If you think a mark you made is too bold or bright or is screaming at you in some way, draw over it with a white water-soluble crayon to lessen the intensity.

12 As a final step, take the papers outside, weight them down with rocks, and seal them with a workable fixative spray. If you plan to use gel medium over the top of your crazy papers in collage, this step is necessary to prevent smearing your marks; if you'll only use adhesive on the backs, feel free to skip this part.

{ KITCHEN COLORANTS }
LOOK NO FURTHER THAN YOUR PANTRY FOR COLORING OPTIONS

Below are a few unconventional colorants that can be used on your projects. While these were all inspired by the kitchen, other options include make-up, house paint, sidewalk chalk, crayons, and finger paints.

COFFEE AND TEA Use coffee and tea to lend an aged, worn, and weathered look to your elements. Sprinkle a few grounds of coffee on a sheet of paper and add a hint of water. The color will wade out from the grounds. You can dip paper into steeped tea for a similar effect.

VANILLA EXTRACT This is another wonderful aging agent that has the added benefit of smelling so sweet.

SPICES Finely ground spices, such as cinnamon, can be used to edge elements or to add a bit of rusty dust to your projects.

FRUITS AND VEGETABLES A squashed raspberry leaves the most remarkable shade of magenta. Blueberry looks lovely too. Beets can be cut in half and carved or etched into to create a glorious red texture stamp.

FOOD COLORING AND EASTER-EGG DYE These will make perfect watercolor paints in a pinch.

UNSWEETENED KOOL-AID Mix one packet with one cup of warm water and use to paint paper or dye fabrics you don't intend to wash. It also gives your artwork the fruity fragrance of childhood.

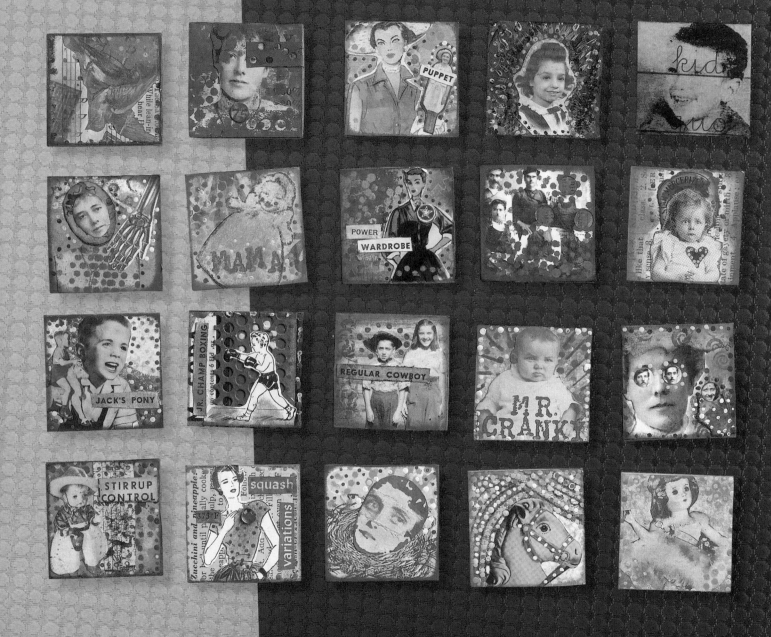

CHERYL'S SCRUMPTIOUS SQUARES

{ BITE-SIZED BITS OF ART }

> "BE FAITHFUL IN SMALL THINGS BECAUSE IT IS IN
> THEM THAT YOUR STRENGTH LIES."
>
> —MOTHER TERESA

I WRITE IN BIG LOOPY LETTERS.

I laugh loudly, and the combination of my hair and heels add several inches to my height. That being said, it may surprise you to know that the mainstay of my creative diet for the last two years has been teensy-weensy 1 1/2" (4 cm) square collages.

I have Debbi to thank for that. When Debbi and I first met, I was awe-struck by her dedication to making art every day. These modular and achiev-able collages were all that I could commit to. Creating in this diminutive scale has been a huge turning point in my artistic journey. It has acquainted me with the previously underexercised concepts of focus and self-restraint.

(Note to Debbi: Stop laughing! I said I "was acquainted," not "had mas-tered.")

On the plus side, working small frees you to create without the worry of wasting expensive canvases or materials (most of the supplies for my collages are from my scrap stash). So you can begin to experiment with imagery, techniques, and materials on a small scale in a nonintimidating way. On the "great opportunity for personal growth" side, working small forces you to edit your work and make careful composition choices.

SMALL. IT'S THE NEW BIG.

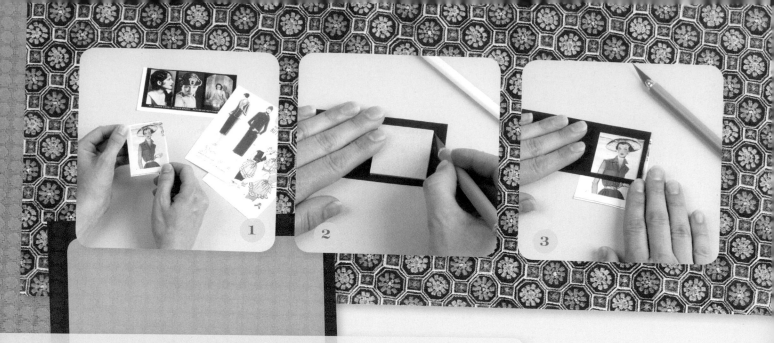

how to MAKE MINI COLLAGES

INGREDIENTS

1 1/2" (4 cm) chipboard squares*

Assorted scrapbook papers

Scrap paper

Collage imagery, paper, and text

Chalk inks

Acrylic paints and watercolors

Stylus**

* If you cannot find precut squares to purchase, consider cutting your own from larger pieces of chipboard or recycling the cover of a hardcover or board book.

** If you don't have a stylus, use an old, dried-up ballpoint pen.

1 Choose an image that appeals to you. You can scan, reduce, and print any vintage pattern or image you find on envelopes, postcards, and photographs to fit on the 1 1/2" (4 cm) area (see image above).

2 Create a handmade viewfinder, which will assist in composing and cutting. Take a scrap piece of cardstock (I like to use black) and cut a 1 1/2" (4 cm) square window out of it by tracing around the small chipboard square with a knife. Now you have a window that you can place over your images to test how it would look cut out (see image above).

3 Use the viewfinder to choose an image (see image above).

4 Place the chipboard square into the window, hold the chip in place, and lift away the viewfinder. Cut around the square. You can then silhouette the remaining image if desired.

5 Choose or create a background paper for your collage. You can stamp a background, cut it from a larger collage, paint it, even use a scrap of fabric. Use the viewfinder if you would like to choose a certain area of the background paper, and follow the previous steps to cut it out.

6 Glue the background paper onto the chipboard square. Glue the main image onto the background. Experiment with the placement, and keep in mind that an image placed a little off-kilter is more interesting.

7 Embellish your collage (both main image and background) with ink, paint, watercolor paints, or bits of text. One thing I like to do is make a border of "paint

pearls" in a couple of colors to visually frame my collage or main image. To make a paint pearl, dip your stylus into acrylic paint and then dot the paint onto your collage. You can go around once with one color and then go back and put another color of paint pearls in between the first.

8 Ink the edges of the collaged chip with chalk ink.

A GREAT WAY TO STORE AND CATALOG YOUR CHIPS IS IN VINYL COIN-COLLECTOR PROTECTORS. THE LITTLE POCKETS IN THE PAGES DESIGNED TO HOLD QUARTERS ARE THE PERFECT SIZE FOR HOUSING YOUR MINI-MASTERPIECES.

{ HEAVENLY LEFTOVERS }
go green in your studio

Our mothers were recycling long before it was in vogue. Back when I was a kid, recycling was called Tuesday Taco Hash Surprise. Like good ole Mom, I enjoy repurposing things a few more times before ultimately pitching them, but out of deference to my family, I put them in my studio instead of a casserole dish. Here are some handy uses for things that are destined for the trash, and you don't have to pick around the peas to enjoy them.

MAGAZINES AND CATALOGS Use them as cheapo cutting mats or cut out the imagery to make collages. This really gives you the freedom to experiment—you're not using that precious vintage postcard, so relax and play.

BAGS Whether you use paper or plastic, use your bags for garbage in your studio or as a protective surface. Bags can be torn open and used to cover your work surface to protect it from flying paint. Another great drop cloth is old wrapping paper that's been crushed or wrinkled—who knew you had so many art supplies cluttering up your closets?

SHIPPING SUPPLIES Bubble wrap can be pressed into wet gel medium to create a wonderful bumpy texture. You can also paint it with a foam brush and stamp it onto your surface. Packing peanuts are fun to stamp in paint too (kids love to do this. And the brown corrugated boxes are infinitely useful—cut them open to serve as a protective work surface; peel back one layer of paper to expose the fluting (wavy layer in the middle), press it into gel medium, and paint for yet another texture; or incorporate it into your work.

FRUIT NETTING You know where I'm going with this. Yes! More texture! But unlike the examples above, the plastic fruit and veggie netting has an additional application. You can use it as a stencil by laying it over a surface and painting over it.

SPICE JAR LIDS You know that little plastic disc on top of your garlic powder that has five holes punched in it so you can shake it onto your salad? It makes a great little paint stencil. Use a foam brush or a sponge to apply the paint and spice up your backgrounds.

FROZEN DINNER TRAYS After eating your 300-calorie din-din, keep the microwavable tray to store the flotsam and jetsam that's rolling around your studio: buttons, small stamp pads, paper bits, etc.

OLD PHONE BOOKS For this little gem of advice, I tip my hat to the effervescent artist Katie Kendrick (see her mixed-media apron on page 116). Katie taught me to use the old phone book pages—yellow and white—to practice non-dominant hand painting. It's great because you can be free as a bird to experiment without worrying about wasting precious papers and canvas. Thanks, Katie, call me!

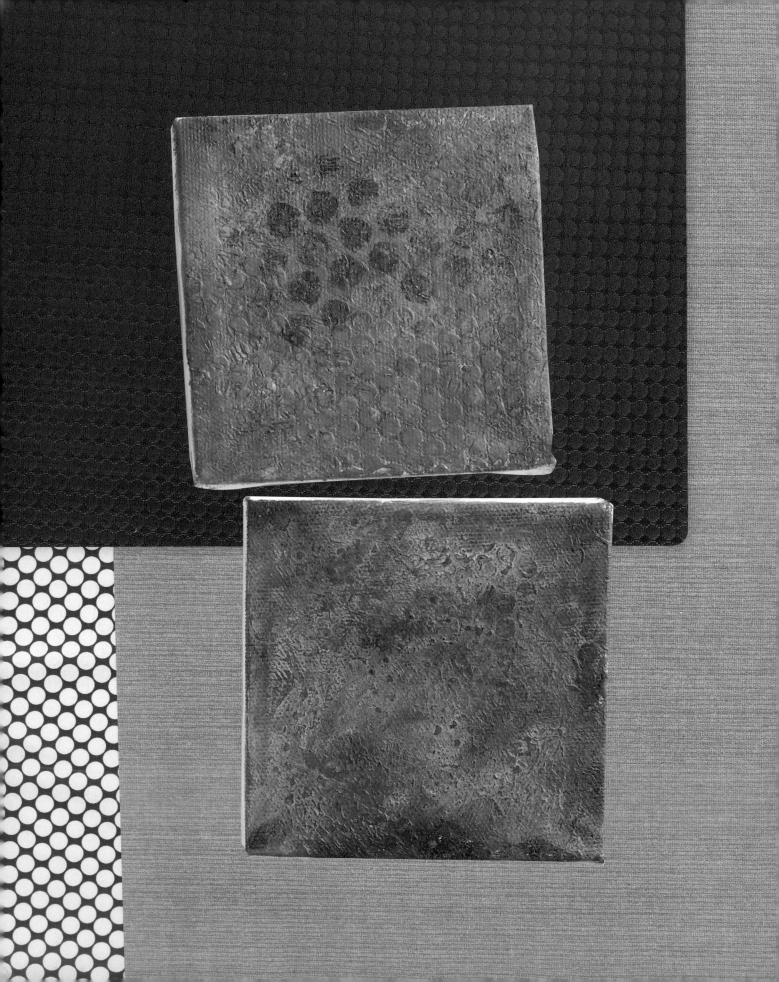

CHERYL'S
BACKGROUND WONDERLAND
{ THE ROUX OF MIXED-MEDIA CREATIONS }

"MANY PAINTERS ARE AFRAID OF THE BLANK CANVAS, BUT THE BLANK CANVAS IS AFRAID OF THE REALLY PASSIONATE PAINTER WHO IS DARING."
—VINCENT VAN GOGH

IF GETTING DIRTY CAN BE SO MUCH FUN, THEN WHY DO SO MANY OF US FEAR THE BLANK CANVAS?

Why is that clean and pristine surfaces are so durn intimidating? Afraid you're going to mess up? Do chefs ever stare at an empty pot and bemoan starting? I'm sure, but eventually they get over it so that no one goes hungry. Now, it's time for you to get over youself. (Besides, if a chef really screws it up, someone may vomit. I highly doubt that anyone is going to toss cookies of your misguided background. You can always paint over it.)

When I have creative block, I just get going. I feel the urge to create, and that urge needs to be set free— my husband and kids can attest to the unfortunate effects of my stifled creativity. It's those first couple of marks and swipes that get my brain going. Rather than sitting there and going "duhhhhhh" over a blank canvas, making a first attempt will at least get me to start making decisions, such as "yeah, I like that" or "holy guacamole, Cheryl, the dog wouldn't even call that art."

Look, I know that blank canvas is the foundation of your finished masterpiece. The first steps are what add that underlying base flavor, the consistency, and the richness to your piece. You are the chef, and the canvas must be primed and seasoned before you can go further. Your paints and textures are the garlic, butter, salt, pepper, and even the mirepoix covering every inch of white. Once it is topped with the star selection, no one notices that it is there; yet if it weren't, your creative dish would be lifeless. So grab your basics—your paints, your texturizers, your imagination—and get cooking!

how to CREATE BACKGROUNDS

INGREDIENTS

Stretched 4" x 4" (10 x 10 cm) canvases or squares of water-color paper

Gel medium

Scrap of mat board for spreading gel medium*

Various textured surfaces**

Acrylic paints

Dye inkpads

Heat gun

Old cotton rag

* If you have any Pampered Chef plastic scrapers, they work great. Old credit cards work well, too.

** You will need these to press into the gel medium—bubble wrap, Wholey Paper, netted mesh fruit bags, sequin design scrap, wire mesh scraps, wads of plastic wrap, etc.

1 Begin by spreading a thin layer of gel medium onto the surface of the canvas with a piece of mat board/scraper (we call this "skimming").

2 Press some textures into the gel medium. The Wholey Paper from Random Arts is definitely a favorite: it's old computer stock with tiny holes in it. I press it into the gel medium layer or lay a sheet of it over the canvas, skim gel medium through the holes, and lift it away. It leaves a lovely raised pattern.

3 Dry your landscaped gel medium with your heat gun. Add another layer if you want more texture. Remember: the thicker you lay it on, the longer it will take to dry. I prefer to add multiple thin layers for that reason.

4 Once you have your desired texture, begin applying paint. Try dripping the paint onto your canvas and working it in. Applying one color at a time, use up to three or four different colors, blotting them with the rag and blending them with fingers or brushes until you have the desired effect.

5 Dry with the heat gun.

6 For some additional texture and interest, use a foam brush to paint onto bubble wrap and then press it onto the canvas. You can also rub the peaks with dye inks or blot paint through the Wholey Paper to create dots of color. Allow to dry.

WHAT TO DO WITH THOSE BACKGROUNDS?

No sense in letting all those finished backgrounds just lie there getting cold. Begin crafting a creative meal by adding to them.

SQUARE IN A SQUARE Glue one of your favorite 1½" (4 cm) collages onto a 4" x 4" (10 x 10 cm) painted background canvas at a jaunty angle. Dry brush acrylic paint around the collage square with a complementary color to visually anchor it.

DOODLE TO MASTERPIECE Try pairing up a couple of your doodles to create a narrative or just a darn cute composition on a painted canvas background. Here you see a doodle-girl and her pet rabbit on a textured background and a couple of cat-thingies on a turquoise painted background with a kite doodled right onto the canvas. Lookie there, just like real art. Yay you!

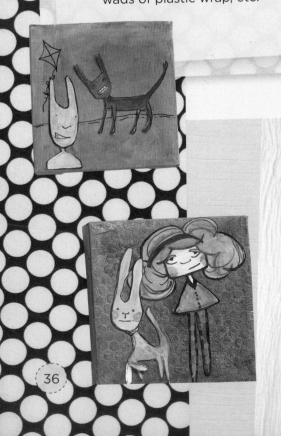

{ QUICK COLOR RECIPES }

USE THE COLOR WHEEL FOR COMBINATIONS
THAT HIT THE SPOT

DINNER FOR ONE When you are in the mood for something quick and simple, reach for a monochromatic color palette. Monochromatic schemes may be based on only one color, but dining alone doesn't have to be sad and lonely. It can be crisp, clean, and classic with the right mix of shades and tints from that one strong, independent color.

A SMOOTH SAUCE Some might call analogous color schemes bland, but those who favor them simply have sensitive and discerning taste buds. Analogous schemes consist of three to six neighboring hues on the color wheel. The effect is very smooth, and they produce subtle color transitions within a piece.

A SPICY MEATBALL For the bold eater, only a complementary color combo will do. Complementary colors lie directly opposite one another on the color wheel. They are an easy way to create bold flavor because of their high-contrast effect.

A TANGY TOPPING If you like things zingy, if you like things unexpected, then allow a color scheme to tempt your "palette." To create it, pick a main color ingredient and then add two handfuls of the colors that sit directly adjacent to its complement.

WELL-BALANCED MEAL It's functional because it fills you up without leaving you bloated or overstimulated; in fact, a dyad color scheme is so balanced that it just makes you feel good. Compose this combo by pairing two colors that are two colors apart on the color wheel (think blue and red).

LITE BUT ZESTY The triad color combination is like the tapas of the color wheel. It's exoticism will tempt your sense of adventure, but, because it's a small plate of food, your senses won't be too over-whelmed. To create this color trio, choose three colors that are evenly spaced along the color wheel.

COMPLEMENTED COMPLEXITY Perhaps your color palette is well developed, and you seek a sophisticated option. A tetrad scheme should be on the menu. Dish it up by combining two sets of complementary colors for a total of four flavorful hues.

MUD PIE Just add equal parts of complementary colors on top of each other and voilà! A big brown mess that no one will enjoy.

CHERYL'S DIVIDE-AND-CONQUER SELF-PORTRAIT
{ QUARTERED AND DRAWN . . . LIKE BUTTA' }

> "BEAUTY IS IN THE EYE OF THE BEHOLDER, AND IT MAY BE NECESSARY FROM TIME TO TIME TO GIVE A STUPID OR MISINFORMED BEHOLDER A BLACK EYE."
> —MISS PIGGY

CHOOSE A MASTERPIECE AND TRY TO REPLICATE IT. IN A WEEK.

In my beginning art class in college, we had to take a copy of famous painting, draw a grid over it, and attempt to reproduce it using the grid lines as reference. I chose Georgia O'Keeffe's *Cow Skull with Calico Roses.* How's that for intimidating?

That assignment was both humbling and frustrating and was single-handedly responsible for my not attempting drawing of any kind for the following twenty years.

First of all, making the reference grid and the drawing grid required patience and precision, two qualities I don't pretend to possess. Also, there was too much to look at: there was color, light and shadow, shape and form. How the heck were we supposed to interpret all of that detail even when using a grid for guidance? Oh, and the best part—there was math involved. The grid squares we drew on the reference image were much smaller than the squares we drew on our poster board, requiring calculations that made my head hurt.

Assuming the professor wasn't just laughing her head off in the faculty lounge, I think I finally understand what we were supposed to glean from that exercise—we were supposed to learn to see. By studying the painting in small bits and not just looking at the whole, we were supposed to hone our artistic eye.

The "Divide-and-Conquer Self-Portrait" was inspired by that assignment with a couple of key simplifications. First of all, there is no math beyond dividing in quarters and there are only four quadrants to sketch, not seventeen million. Second, you will be using a high-contrast black-and-white image as a reference—no light or color to distract you. Third, you are sketching an image that isn't revered by art historians, though certainly by many loved ones: your own face.

how to DIVIDE AND CONQUER

INGREDIENTS

Four 4″ x 4″ (10 x 10 cm) stretched canvases

One sheet of watercolor paper cut into four 3 1/2″ (9 cm) squares

High contrast print of portrait subject, approximately 8″ x 8″ (20 x 20 cm), for reference

Fine-point waterproof black marker

Red marker

Black acrylic paint

Caran d'Ache water-soluble crayons

Glue stick

1 Paint the sides and edges (about an inch in from the sides) of the stretched canvases with black acrylic paint. Allow these to dry.

2 Use image-editing software to create the high-contrast reference photo. You also can use a photocopier to enlarge the image and make a high-contrast copy. Basically, you want to lose a lot of the detail, creating an image that looks as if it's been rubber-stamped.

3 With a red marker, quarter the image by drawing a big plus sign through the center of it.

4 Fold the photo into quarters along the red line so that only one quadrant of the figure is shown. Sketch the image from that quadrant onto one of the squares of watercolor paper with pencil. Once satisfied, ink over the lines with the black marker, allow to dry, and erase all pencil marks.

5 Repeat this step for the other quadrants. Don't worry if the images don't match up or are asymmetrical—this will add to the appeal of the final result, and admirers will swoon at your avant-garde technique.

6 Color in the quadrants one at a time with water-soluble crayons and a light touch. You can add colors on top of each other. For example, I colored in a skin tone and then added some pink to the cheeks before blending with water.

7 Blend the colors with a damp paintbrush.

8 After you have colored and blended all four quadrants, adhere them to the four canvases with a glue stick.

9 Decide where to display your finished piece. Hang the canvases on a wall in a vertical or horizontal arrangement or in a square. You can even set them on the coffee table so guests can re-arrange your face.

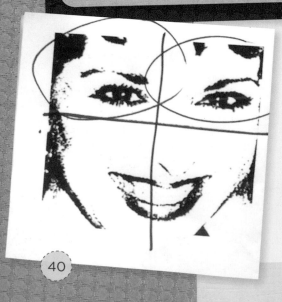

{ MOOD MUSIC }
music to mix media by

Here's a sample of what you may hear in my studio or on Debbi's iPod. And no, we're not going to make you a mix tape.

DEBBI'S MUSE-IC RECIPE
Generous helpings of the following albums, artists, and songs:

- *Little Creatures* by Talking Heads
- *Baptism* by Lenny Kravitz
- *Paul's Boutique* by The Beastie Boys
- *Tattoo You* and earlier by the Rolling Stones
- "Boom Like That" by Mark Knopfler
- "Sultans of Swing" by Dire Straits
- Throw in a lil' Kanye, a bit of Janis, a dash of Jack Johnson, and two scoops each of Elvis Costello, Sara Bairelles, and Suzanne Vega. Mix vigorously.

THE ONLY REMOTE CORRELATION BETWEEN MY LIST AND DEBBI'S? DIANA KRALL AND ELVIS COSTELLO ARE MARRIED.

—CHERYL

CHERYL'S STUDIO SING-ALONG

- *Absolute Torch* and *Twang* by k.d. lang
- *Fallen* by Evanescence
- *Time/Offerings* by Third Day
- *Come Away With Me* by Norah Jones
- *Misterioso* by Incendio, featuring Jim Stubblefield
- *Nickel Creek* by Nickel Creek
- *Gipsy Kings* by Gipsy Kings
- The three albums *It's Time*, *Irresponsible*, and *Michael Bublé* by Michael Bublé
- *Ella Fitzgerald Sings the Cole Porter Song Book*
- *The Look of Love* by Diana Krall
- *A Voice in Time: 1939-1952* by Frank Sinatra
- The *Big Night* soundtrack
- Anything by Tony Bennett, Mel Tormé, Billie Holiday, or the Glenn Miller Orchestra. Swing, baby! Take the A Train and don't forget to buy War Bonds!

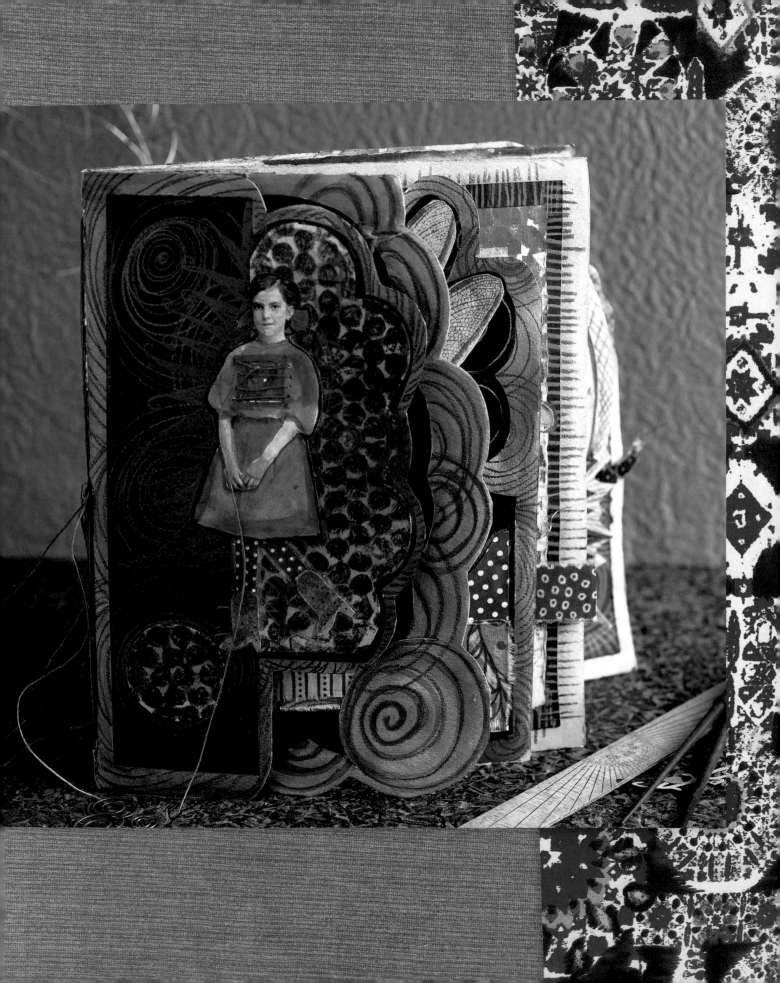

MAIN COURSES

D: Mmmmm . . . what smells so good?

C: I suppose it could be my Aunt Betsy's Spanikopita (see page 81 for the recipe), but I'm thinking it's all of the wonderful ideas in this chapter.

D: Really, what's on the menu?

C: Only a smorgasbord of media and methods including collage, assemblage, and bookbinding. I hope the Artistic Appetizers whetted our readers' appetite because as we serve up the main course, we're going to build on the techniques and ideas from that chapter.

D: Is this the chapter where I get to start using my terminology, such as "visual rhythm" or "tertiary color"?

C: Just because you teach art, you like to throw around all the words and stuff, don't you? Come on, Debbi, you know you already started using those words in the introduction. Sheesh.

D: That stuff is important, just as important as your brilliant ideas for how to art shop at flea markets. You are such a pro at finding ephemera, such as labels, postcards, books, and photos as well as objects that can be used in assemblage pieces. Our readers will be glad for the education.

C: Well, before adjourning this meeting of the Mutual Admiration Society, let me praise your thirty-minute meal ideas for creating a piece of art every day. I will forever be awed by your commitment to bringing art into this world on a daily basis. How many years is it now, five?

D: And counting. Thank you for the compliment. To me, art is like food. I need a little bit every day to survive. The creativity meals we suggest in this chapter are definitely a great way to feed the hunger. And there are so many different recipes . . . comfort food, soul food. I just hope everyone saves room for dessert.

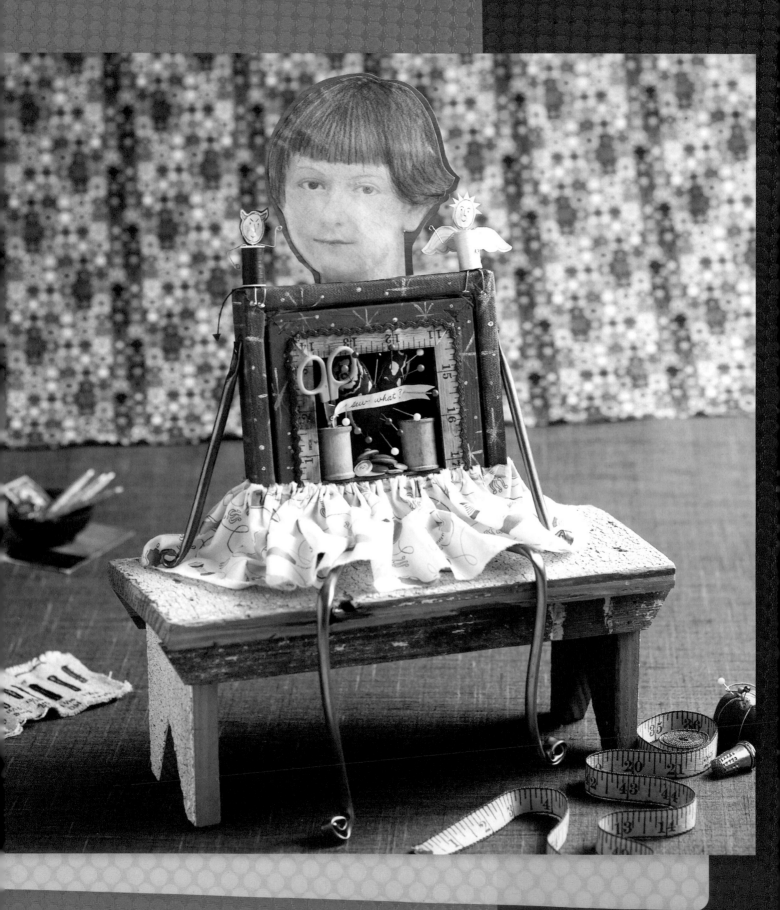

DEBBI'S RELIQUARY GIRLS
{ NEVER MAKE ART ON AN EMPTY STOMACH }

"IF I CREATE FROM THE HEART, NEARLY EVERYTHING WORKS;
IF FROM THE HEAD, ALMOST NOTHING."
—MARC CHAGALL

I JUST LOVE THESE DOLLS.
The niches. The serious heads on the silly forms. The bent tubing limbs and the wonderful fabrics mixed with metals. They are built, not glued together. They each tell a story from my everyday life, not some dreamed up, wild, poetic tale. For me, they really are an example of allowing the truth to spill from your artwork—that's where the soul comes from.

Throughout history, reliquaries have been created as containers for precious artifacts of cultural significance. These assemblage dolls might not hold any saint's tears, but they can display odds and ends that you love to look at.

The sitting girl is the original reliquary doll; I created her for my husband, J.R. He marvels at how I can sew entire quilts and purses and skirts from scratch, but can never seem to find the time to sew on his buttons.

"Sew what" in the niche is actually me saying to him, "You want me to sew what? I've got art to make!" The little thread angel is telling me to be a good girl and sew on the stinkin' buttons and bake a pie and run the sweeper, while the thread devil is telling me to make something frivolously cute.

When Cheryl saw these finished pieces, she asked me, "What exactly did you tell the guy at the home-improvement store that you were doing with all of the copper tubing?" It was my husband who really required all the explaining. I asked him to help me with the drilling (keep in mind that the copper wire and tubing are heavenly to work with because they are very easy to mold), and boy, was he ever full of suggestions and questions, beginning with "why would you . . ." I thought about crediting him as my collaborator on this one.

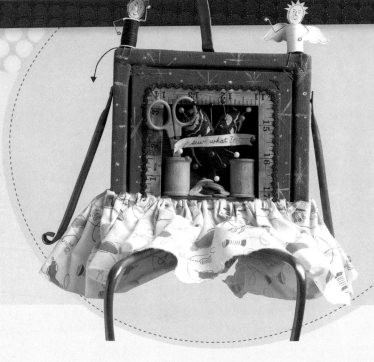

INGREDIENTS

6" (15 cm) canvas

Acrylic paint in contrasting colors

Watered down brown acrylic paint

White acrylic paint

Paper towels

Small piece of matte board
(if needed)

Objects for the inside of the niche

Scrap canvas (optional)

1 Paint the entire canvas—back, front, and sides—with one color of acrylic paint. Allow to dry. Note: the back of the canvas is actually the front for this project. The recessed area in the back of the canvas will become the niche, or home, for your little treasures.

2 Paint the inside of the niche with a contrasting color to give it depth and distinction. Allow to dry.

3 Dip a fine brush in the white paint to draw a pattern all over the canvas. Try dots, stripes, or curlicues. Allow to dry.

4 Brush over small areas at a time with watered-down brown acrylic. Wipe off with paper towels. While you are at it, treat the cardstock (you will use this later when creating the neck and face of the doll) the same way, back and front. If you are making the standing girl, paint a sturdy scrap of wood you will use as a base.

5 Make sure your niche has a flat floor for your objects. Some of the stretcher bars that give the canvases their rigid

frame are square, while others are rounded. If yours are rounded, cut a small piece of mat board to fit inside and paint it to match your niche. Once dry, adhere it to the inside of the niche and allow the glue to set.

6 Gather objects for the niche. This is totally your call. You can think of your niche as an altar paying tribute to an idea, a friend or loved one, or yourself. For "Sew What?" I used all types of cute little sewing tools and supplies. Most came from a dollar-store sewing kit. The tiny angel and devil were created by placing a little air-dry clay in the center of the spools in which I stuck bits of wire for the arms, legs, and necks. The faces are made in the same manner as the girls' faces. To create the door covering the niche on the standing girl, tack a scrap of canvas to the frame. The small book inside is bound in the same style as the Peek-a-Boo Collage Book (see pages 82–87) and filled with photos.

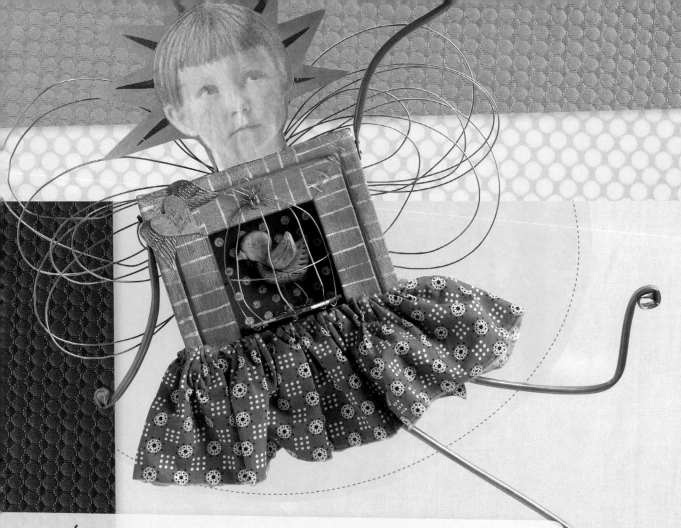

how to FASHION THE BIRD CAGE

INGREDIENTS

Oven-bake or air-dry clay

Acrylic paint

Mat board (can be scrap)

Copper wire

Wire cutters

Hammer

Copper tacks

Chipboard scrap

Needle-nose pliers

Awl

1 To make the bird for the flying doll, use an oven-bake or air-dry clay to design a bird. Before baking or drying, poke two holes in the bottom of the bird with some scrap wire so you can add legs later. When the bird is dry, paint it, and glue two wire scraps into place for the legs.

2 To create the floor of the birdcage, cut a half circle of mat board to fit just inside the niche. Paint and wrap the curved edge with copper tape.

3 Put the half circle in place and mark where the canvas frame touches it. Remove and use an awl to poke a hole through the half circle, near the edge. Just outside of the marks you made, make another hole. Center another hole in the spaces between, for a total of five. Cut five 6" (15 cm) lengths of copper wire. Use pliers to put a little curl in one end of each 6" (15 cm) length (see image right).

4 Hammer a copper tack in the wooden frame above the niche. Don't sink it completely; leave about ¹/₄" (6mm) showing to wrap the wire around when making the cage (see image right).

5 Glue the half circle into the niche. Glue the bird inside the niche. Allow to dry for a couple of hours; this will make building the cage so much simpler.

6 Thread the uncurled end of each wire up through the bottom of the half circle. Curl this end of the wire. Curve the wires in the shape of a birdcage and wrap the ends around the exposed tack. After you have wrapped all, tap the tack lightly with your hammer to secure (see image right).

7 Cut at least two more 6" (15 cm) lengths of wire to weave in and out of the vertical wires. Snip the end to fit, and secure it by poking through the canvas.

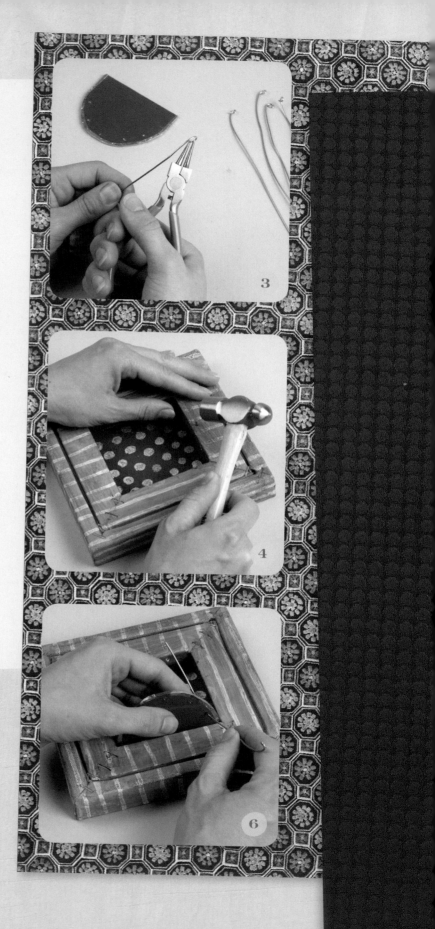

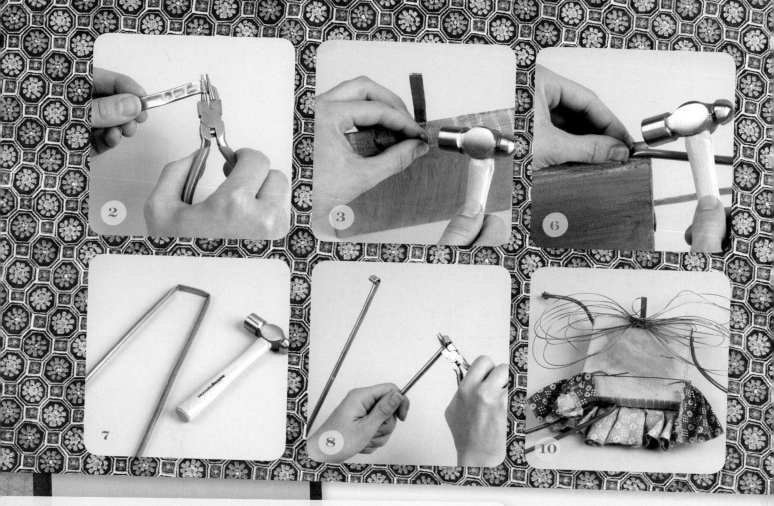

how to CONSTRUCT THE BODY

INGREDIENTS

Copper tubing

Copper tacks or screws

Drill

Hammer

Needle-nose pliers

Acrylic paint, 2 colors, plus brown and white

1 Cut two 6" (15 cm) lengths of copper tubing for the arms. Cut a 24" (61 cm) length for the legs. Use about 4" (10 cm) of the leftover to make the neck.

2 For the neck, use a hammer and a strong, flat surface to flatten the short piece of tubing. To bend $1/2$" (1.3 cm) of the flattened tubing 90 degrees, use pliers or let the end of the tubing hang over the edge of your workbench and hit it with the hammer until it bends (see image above).

3 Drill a pilot hole through the $1/2$" (1.3 cm) end of the tubing and another in the top of the canvas, centered about $1/4$" (6 mm) from the front edge. Remember that the side with the niche is the front of the canvas in this project (see image above).

4 Use a tack or a small screw to attach the neck to the canvas.

5 For the arms, flatten $1/2$" (1.3 cm) of each end of the 6" (15 cm) pieces of tubing. Grasp one of the ends with your pliers and make a curlicue in the end for a hand. Drill a pilot hole in the other end. Repeat for the other arm.

6 Drill pilot holes on the sides of the canvas, centered about 1/2" (1.3 cm) from the top edge. Use tacks or screws to attach the arms. For the standing girl, bend her elbows to put her hands on her hips. For the flying girl, bend the arms to imply a gesturing motion. Leave them straight for the sitting girl (see image page 49).

7 For the legs, use your hammer to flatten out a scant couple of inches in the center of the 24" (61 cm) piece. Drill two pilot holes in the flat area. These two points of attachment will create stability in the legs (see image page 49).

8 Flatten out the ends and use your pliers to make curls for feet (see image page 49). For the standing girl, give her flat feet to stand by flattening 1" (2.5 cm) of the copper tubing, leaving 2" (5 cm) on the end with which to create a curlicue. Drill pilot holes in the feet and in the wooden base. Attach the girl to the base and bend the tubing slightly to get her to stand straight.

9 To attach the legs, drill two pilot holes in the lower edge of the canvas. Use the ones you drilled in the tubing for the legs as a guide. For the standing girl, center the pilot holes in the underneath side of the frame. For the sitting girl, center the pilot holes in the front on the lower edge of the canvas. For the flying girl, place the holes toward one end of the underside.

10 The other copper element you might use would be wire for the wings of the flying girl. Make a series of free-form figure eights with the wire. Gather the eights together and use the last few inches of copper wire to wrap around their center. Gently pound the center with your hammer to secure. Copper is very soft, which makes it easy to bend and shape, but it's also easy to break if you are overzealous with the hammer (see image page 49).

how to FINISH THE GIRL

INGREDIENTS

Photocopied face, sized to about 4" (10 cm)

A piece of 6" x 36" (15 x 92 cm) fabric

Embroidery floss

Embroidery needle

Watercolor paints, colored pencils

Cardstock

1 To make the skirt, needle-and-thread gather one long edge of the fabric with a medium-sized running stitch. Adjust the gathers to fit around the canvas. Glue the skirt to the canvas just below the niche.

2 Use watercolor paints or colored pencils to add a flush to the cheeks and lips of the photocopied image that you will use for the head. If satisfied, cut it out, making sure to leave a bit of the neck. Leave more than you think you will need and trim to fit later.

3 Dot white glue around the edges of the head, skipping the neck edge. Glue to the cardstock. Cut the neck edge flush, but leave a narrow border of the cardstock showing elsewhere. Cut a big zigzag for the halo on the flying girl.

4 Hold the head up to the neck to see if the neck is the right length. Trim as necessary. Trust your eye. Cut a notch out of the lower edge of the neck on the cardstock side only, so the head will sit flat. Slip the head over the neck.

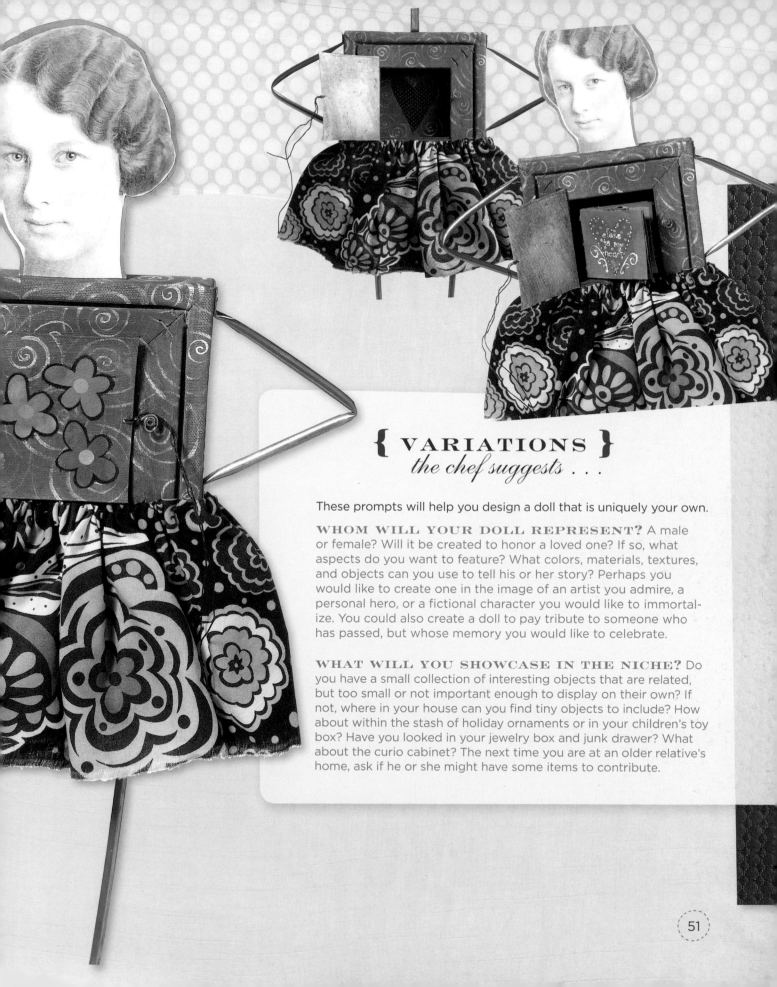

{ VARIATIONS }
the chef suggests . . .

These prompts will help you design a doll that is uniquely your own.

WHOM WILL YOUR DOLL REPRESENT? A male or female? Will it be created to honor a loved one? If so, what aspects do you want to feature? What colors, materials, textures, and objects can you use to tell his or her story? Perhaps you would like to create one in the image of an artist you admire, a personal hero, or a fictional character you would like to immortalize. You could also create a doll to pay tribute to someone who has passed, but whose memory you would like to celebrate.

WHAT WILL YOU SHOWCASE IN THE NICHE? Do you have a small collection of interesting objects that are related, but too small or not important enough to display on their own? If not, where in your house can you find tiny objects to include? How about within the stash of holiday ornaments or in your children's toy box? Have you looked in your jewelry box and junk drawer? What about the curio cabinet? The next time you are at an older relative's home, ask if he or she might have some items to contribute.

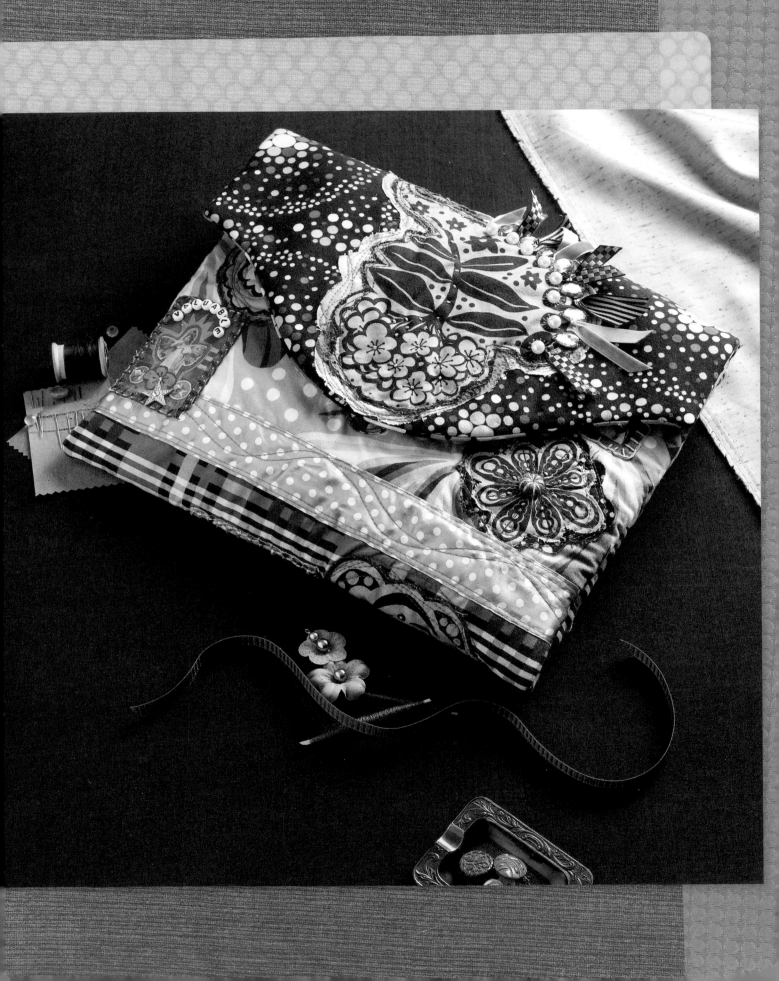

DEBBI'S QUILTED CLUTCH
{ WHO NEEDS CAVIAR WHEN YOU'VE GOT BEADS }

> "USE WHAT TALENTS YOU POSSESS; THE WOODS WOULD BE VERY SILENT IF NO BIRDS SANG EXCEPT THOSE THAT SANG BEST."
> —HENRY VAN DYKE

THIS CLUTCH COULD BE A METAPHOR FOR MYSELF: A LITTLE QUIRKY ON THE OUTSIDE AND FULL-ON WILD WOMAN ON THE INSIDE.

One of the most exciting parts of this project was picking out fabrics that truly said ME! The fabrics are the springboard for the creative design. I took something I love, in this case, the flower print fabric, and allowed it to guide my embellishment choices and techniques. It was the pattern that directed my beading and stitching, not my little Debbi voice saying, "You should put something here or there."

This clutch is the epitome of homemade but the antithesis of the image conjured by the phrase "hand-made, quilted clutch." It's a handmade quilted clutch for the cool and sophisticated. The really great thing about this clutch is that you can alter the size and make a smaller clutch (didn't there used to be a commercial where a schoolmarm type told us that "no reasonable woman would be seen carrying a bag larger than her head"?), a laptop clutch, or, in Cheryl's case, an iPhone clutch (she got one for Christmas and can barely get through a conversation without dropping an "oh, I can do that on my iPhone").

There has been an explosion of cute fabric lately. I've seen the variety of colors and patterns even tempt a nonsewer to pick up a few (or more) yards. If you are "that girl," a purse is a great way to warm up your sewing skills. Plus, a purse is one-size-fits-all, no measuring or figuring out what size pattern to buy, so it makes a great project and a great gift.

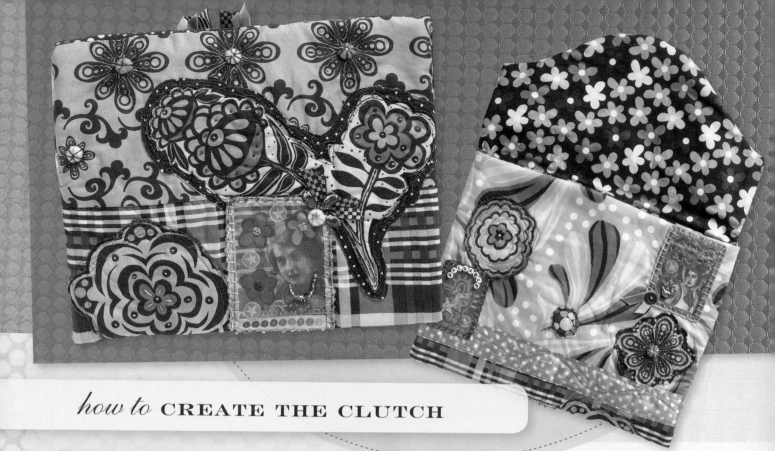

how to CREATE THE CLUTCH

INGREDIENTS

Pattern on page 126

Two 15" x 26" (38 x 66 cm) pieces of fabric (one for the interior and one for the exterior)*

15" x 26" (38 x 66 cm) piece of quilting fleece

Assorted fabric scraps for appliqué

Fabric shears**

Sewing machine

Two colors of threads***

Two small magnets

Needle

Heavy handsewing thread, such as waxed-linen bookbinding thread

* It's a good idea to wash, dry, and press new fabrics before working with them.

** If you work with fabric, purchase a pair of dedicated fabric shears and only use them for cutting fabric.

***Choose one that matches your fabrics for sewing the seams and one that contrasts strongly with your exterior fabric for the freeform appliqué and embroidery.

1 Fold the exterior fabric in half lengthwise and use the pattern on page 126 to cut a rounded triangle from the end you want to be the flap of the clutch. Pay attention to which way a directional print is facing. You will want it to be right side up as the flap folds over the clutch. Cut along the fold.

2 Open the exterior fabric and pin it to the fleece and lining fabrics. Cut them to match the shape of the exterior fabric and unpin.

3 Set aside the lining fabric and pin or baste the fleece and exterior fabric together, right side out.

4 Add stitched appliqués with a sewing machine. Using the motif on the fabric as your guide, create doodles and drawings with thread in a contrasting color from the fabric. The clutch is small enough to be easily maneuvered under the presser foot. While any variety of stitches will work fine, using a straight stitch and the reverse button for tracing over and over your stitching will give that scribbly, intentionally imperfect look. Draw anything, from simple, geometric shapes to leaves and flowers. You don't need to cover the purse with stuff; a scattering to accent the pattern is all you're after. If you are unsure of your freehand skills, draw your designs with chalk or a disappearing quilting marker and trace them.

5 For the closure, make two small appliqués and messy-stitch the layers together. I used layered circles in colors I liked with the red-orange exterior fabric. Place one of these appliqués in the center at the bottom of the flap. Stitch about three-quarters of the way around, then slip one of the magnets under the appliqué. Finish stitching. Retrace the sewing a couple of times to keep the messy look going. Place the other appliqué and magnet combo on the opposite end of the exterior fabric, with the magnet centered about 5" (13 cm) from the end so that it matches with its opposite.

6 Add a few more appliquéd shapes to the clutch exterior. Play around inside the spaces between the motifs of the fabric and the embroidery.

7 If you wish to add any beads, buttons, baubles, doo-dads, transfers, or trinkets to the purse, do it before going any further. This will keep your attaching mechanisms hidden, so you don't have to worry about keeping your beading stitches neat.

8 Place the lining fabric face down over the clutch exterior. Beginning about halfway down one of the long sides, sew all the layers together with a quarter inch seam allowance, stopping 4" (10 cm) or 5" (13 cm) from where you began.

9 Snip the seam allowances off the corners and turn the purse right side out through the opening. Use a crochet hook, bone folder, or other dull tool to pop out the corners for a neat look. Handsew the opening closed.

10 Fold the straight end up 8" (21 cm), right sides together. Handsew each end with heavy thread. Turn right side out. Test the magnet closure. Isn't that cool?

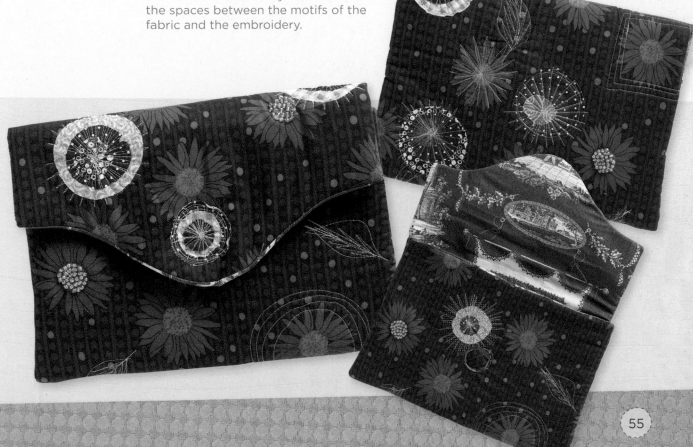

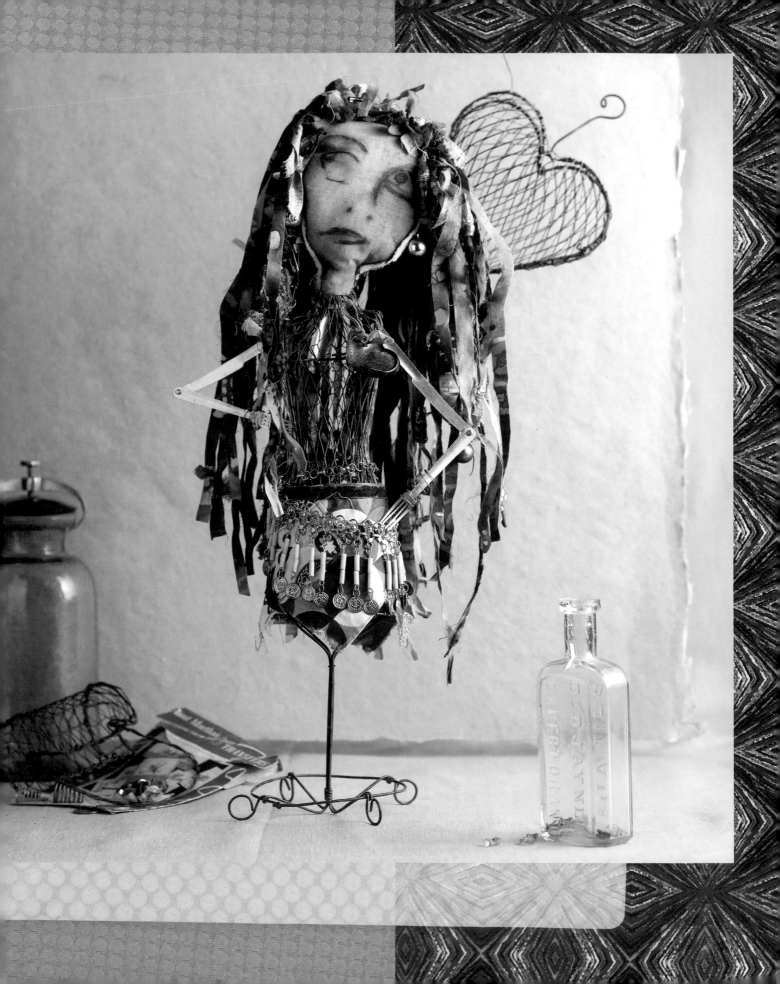

CHERYL's MIXED-MEDIA DOLL
{ MAKING SOMETHING OUT OF EVERYTHING }

"RATHER THAN OFFERING ASSURANCE, EACH NEW ACHIEVEMENT AND SUBSE-
QUENT CHALLENGE ONLY SERVED TO INTENSIFY THE EVER-PRESENT FEAR OF
BEING FOUND OUT. 'OH MY GOD,' I THOUGHT, 'I'VE BEEN UNMASKED!'"

—DR. VALERIE YOUNG
FOUNDER, CHANGING COURSE, AN ORGANIZATION DEDICATED
TO HELPING PEOPLE OVERCOME THE IMPOSTER SYNDROME

"LOOKS LIKE YOU'VE STILL GOT THEM BUFFALOED, HUH, KID?"

My dad likes to joke with me after each new accomplishment. I know he is proud of me, and I have some faith in myself, but on top of all of that lies the Imposter Syndrome. I feel that any success I have is a fluke and that eventually someone will point at me in a crowded room and shriek, "She's a sham!"

I call this doll "Syndie Imposter." I was just messing around in my studio, still in my pajamas, and then, poof! She became the first project I completed for this book. At first glance she is all bravado. Her hands are on her hips as if to say, "Yeah, I can do anything. Try me." But her fragile heart is on the outside of her body, and there are butterflies in her stomach. Is her expression one of smug confidence or (gulp) apprehension?

Syndie is unique and ubiquitous all at once. Basically, she is a collection of my own personal found objects and assorted junk; therefore, she tells my own personal story. Get your own junk to tell yours. No stockpile of doll-making debris in your craft area? Rummage through your junk drawer, jewelry box, sewing supplies, and lint catch. Look at common doo-lollies with new eyes. Challenge yourself to use only what you find in or around your house or under the seats in your car. If you can't find the exact item you see used here, wing it!

how to MAKE THE FACE

INGREDIENTS

Black marker

Scanner, computer, and printer

Iron

Caran d'Ache water-soluble crayons

Gesso

1 Using a black marker, sketch out several faces on plain paper. It doesn't have to be a world-class rendering, so have some fun with it. Symmetry, reality, and your inner critic are all on vacation.

2 Scan your favorite sketch into your computer. If you drew it to the actual size you want the head to be, you can just print it out onto the paper-backed fabric (see instructions below). If not, you may want to play with the size at which you will ultimately print it by trying a couple of drafts on plain paper before running your fabric through.

3 Don't peel the fabric off the paper once you've printed it; first, press it fabric-side up with a hot iron to heat set the ink.

4 Trim around the outline of the face with scissors, with a $^3/_4$" (2 cm) margin seam allowance. Now you should have a sort of lightbulb shaped piece of paper-backed fabric.

5 Without removing the paper backing, lightly color in the face with water-soluble crayons, coloring in the skin first. Add some blush to the cheeks and color to the eyes and lips.

6 Wet your brush in water, then dab it in some gesso, then back in the water, diluting the gesso on your brush. Paint over the crayon-colored face with the watered-down gesso. This is a great tip I learned from DJ Pettitt. It adds opacity to the watercolor crayon, and the colors blend beautifully.

7 Now, for the three most dreaded words in any project: ALLOW TO DRY.

how to STABILIZE FABRIC

INGREDIENTS

Muslin

Palette paper

If you don't have any store-bought stabilized fabric but have some muslin and palette paper on hand, you can easily make your own. Palette paper is poly-coated paper on top of which you can mix paints. It comes in pads and can be bought at craft or art-supply stores. Palette paper, unlike freezer paper, doesn't curl up and fight the printer. So there's less cursing and more crafting.

1 Cut a piece of muslin to 8 $^1/_2$" x 11" (22 x 28 cm).

2 Cut a piece of palette paper to match. I use 9" x 12" (23 x 31 cm) palette paper for minimal trimming.

3 Lay the muslin on top of the shiny, plastic-coated side of the palette paper.

4 Press with a hot iron until the fabric and paper are adhered.

5 Run through the printer like you would other specialty papers.

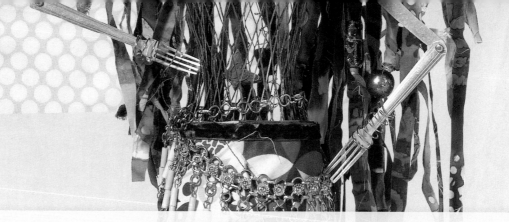

{ GONE JUNKIN' GROCERY LIST }
CARRY ALONG THESE SUGGESTIONS AS YOU STROLL
THE AISLES IN SEARCH OF CREATIVE FOOD

Flea markets, swap meets, estate sales, or, depending on where you're from, tag, yard, or garage sales are all fertile hunting grounds for first-class junk. The best finds are often hidden in musty boxes heaped with stuff that should have been garbage in the last century.

I love to junk at Lakewood 400, an antique marketplace in Atlanta, but in addition to the Rodeo Drive of Rusty, another favorite purveyor of fine junk is Random Arts in Saluda, North Carolina, or online at randomarts.com. They have done the digging for you and have bins and drawers filled with unique rubbish relics. Here's a list of the kind of stuff that has followed me home from either or both of these wonderful mixed-mania marts.

✧ Antique door hinges

✧ Tiny vintage glass tree ornaments (see Mixed-Media Doll on page 56)

✧ Old keys, skeleton and otherwise (see Keepsake Box on page 88)

✧ Ivory mahjong tiles

✧ Brass and zinc numbers

✧ Old matchbooks

✧ Civil War–era clay marbles

✧ Old tin tea sets and kitchen ware (see Mixed-Media Doll on page 56)

✧ Vintage postcards (see Artsy Game on page 96)

✧ Quail eggs

✧ Buttons

✧ Bottle caps

✧ Playing cards

✧ Wooden checkers, spinners, chess pieces (see Artsy Game on page 96 and inset below)

✧ Old sewing patterns

✧ Victorian cabinet cards (see Dimensional Collage on page 76)

✧ Small metal springs

✧ Chandelier crystals

✧ Stars cut from propane tanks (see Dimensional Collage on page 76)

✧ Dolls

✧ Old catalogs, magazines, and hymn books

✧ Wooden spools and sock darners

✧ Metal wall brackets

✧ Tintypes

✧ Wooden printing blocks

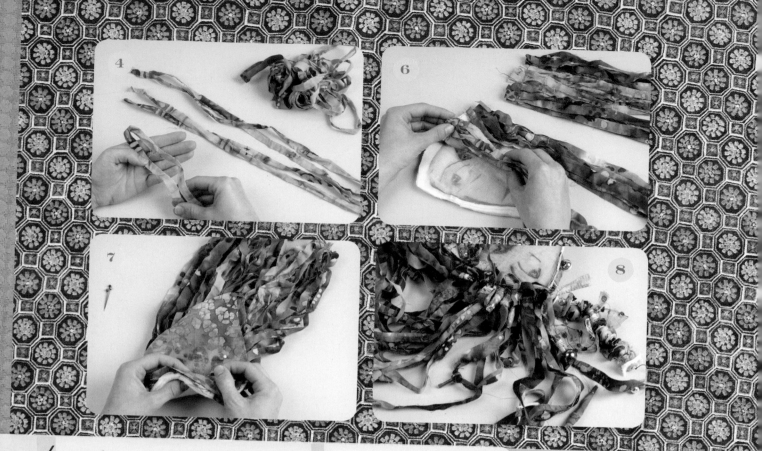

how to CREATE THE HEAD

INGREDIENTS

Face from the previous set of instructions

Batting

Fabric for the back of the head

Fabric strips for hair

Foamcore, a little smaller than the face

Sewing machine

Thread

Handsewing needle

Beads

Buttons

Serving spoon

Adhesive hook and loop tape

1 Okay, for those of you dying to peel the backing off of the fabric, now's your chance: Peel it off! But save that paper backing. We're gonna need it.

2 Use the paper backing as a pattern to cut the batting. Pin it to the batting and trim the same shape and size as the face. Do the same for the fabric you intend to use for the back of the head.

3 To give the head stability, cut a piece of foamcore that's 25% smaller than the pattern. This will fit in the head once it's sewn up, giving it rigidity.

4 Create the hair in hanks, like little tie-dyed hair plugs. Take the tail of the fabric strip and wind it around your thumb and elbow three or four times, as if you were winding up an extension cord, and cut it from the skein. You now have several large loops of fabric strip (see image above).

NO EARS??

THAT'S NO EXCUSE NOT TO ACCESSORIZE.

—CHERYL

5 Lay one end of the looped fabric down on your machine and, starting about ½" (1.3 cm)down from the looped end, sew the loops together, being sure to catch all the ends. Once sewn together, you can cut the loops on the nonsewn end to create locks for your doll. Repeat several times—this doll has about nine hanks.

6 To sew the head together, lay the batting on your work surface and lay the face right side up on top of it. Arrange the first hank of hair where you want the hairline to start and overlap the remaining hanks until you've completed the hairline around the face (see image left). Lay the backing fabric right side down on top of the batting and pin (see image left). Sew the top of the head ONLY where there is hair. Take care not to sew the tendrils up in the hairline (see image left).

7 Turn the right sides out. Sandwich in the foamcore between the batting and the back piece. Top stitch the face together on either side. You'll see the batting—it's okay, part of the charm. Trim around the edges of your stitching, evening up the shape (see image left).

8 Cut some 2" to 3" (5 to 8 cm) lengths of fabric strips as well as other ribbons and tie these short strips into the hair at the hairline. String beads and small keys onto the hair strips and knot them in place. Finally, for every two mixed-media locks, alternate stringing beads and buttons onto some heavy thread. Tie one end onto a small safety pin and pin it to the head. Whipstitch some small ornaments or beads on for earrings (see image left).

how to FINISH THE FIGURE

INGREDIENTS

Wire dress form. The one shown is about 16" (41 cm) tall.

Wire

Hammer

Nail

Brads

Springs

Old necklace

Butterfly beads

4" (10 cm) fabric squares

Ribbon

Miscellaneous embellishments, such as heart-shaped glass bead, utensils for limbs, etc.

1 String butterfly beads onto wire, wrap around a paintbrush handle to spiral the wire, and suspend inside the mannequin form.

2 Using a hammer and nail, hammer holes into both ends of the knives and one end of the forks. Connect at the elbow with brads. Slip some spring bracelets over the tines. Secure the shoulders to the dress form with wire.

3 Put fork hands on hips of form. Feel sassy.

4 Sew skirt out of several 4" (10 cm) squares. Whipstitch closed in back. Fray edges of skirt with pin.

5 Wrap necklace around waist for belt.

6 Tie glass heart bead onto outside of wire form with ribbon.

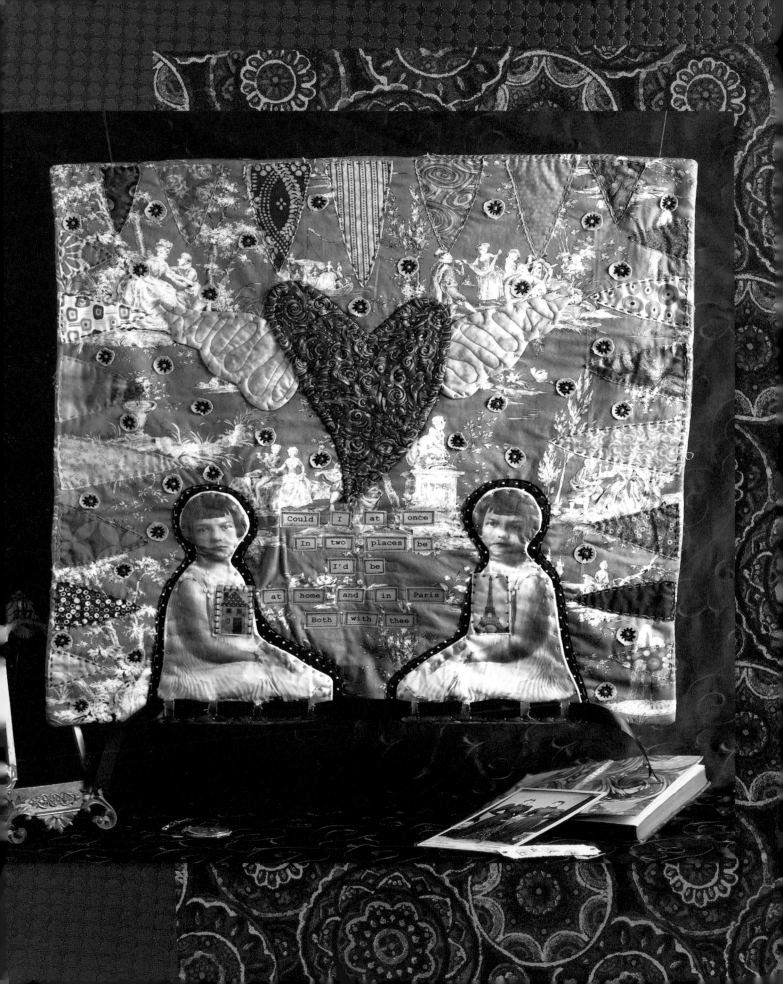

Could I at once
In two places be
I'd be
at home and in Paris
Both with thee

DEBBI's ART QUILT
{ EQUAL PARTS COMFORT AND SOUL FOOD }

> "HE WHO LOVES, FLIES, RUNS, AND REJOICES;
> HE IS FREE, AND NOTHING HOLDS HIM BACK."
> —HENRI MATISSE

ALL OF THE REALLY PROLIFIC BOOK ARTISTS I KNOW ARE GREAT STORYTELLERS.

Since I began making books in 2002, I have had opportunities to study with the masters of the craft. Some of the best moments of my life have been spent hearing Jim Croft or Dolph Smith spin a fantastic yarn about the Merchant Marines or Marilyn Monroe. I aspire to be a storyteller. And that presents a problem. I have lived in the same small town in Indiana my entire life. I have never been to Europe, been arrested, or been on TV. By any standards, my life is small and simple (and happy). What story could I tell? I can only tell you small truths and hope that you understand.

Every summer, I am privileged to teach at Hummingbird Art Camp in Jemez Springs, New Mexico. This beautiful music and art camp in the mountains was founded by the Higgins family in 1958 and is directed by the lovely Teena King. It brings together a variety of artists from all over the country to teach a week's worth of art to about 100 kids.

I designed this quilt on a flight from New Mexico back to Indiana. Another year of art camp had come to a close, and I was overcome with conflicting emotions to the point of tears. I was so tired and ready to get home to my husband and kids, but I was already missing those red mountains and my beloved art-camp friends. I was truly torn between two places. Once I got myself together, I pulled out my sketchbook and drew the first draft of this quilt. It doesn't tell a wild and windy tale of international intrigue; it only tells you of a feeling I had one July afternoon. Perhaps you, too, have felt the pull of wanting to be two places at once or of a similarly bittersweet emotion.

INGREDIENTS

Eiffel Tower image, house image, and image of girl*

Computer, scanner, image-editing software, and printer

Image transfer sheets suitable for your printer, inkjet or laserjet

Iron

³/₄ yd (0.69 m) muslin

* You can photocopy or scan copyright-free images from magazines and books, use one of your own images, or download an image from the Internet

1 Scan the photo of the girl. Using your image-editing software, resize as desired and duplicate the image. Reverse the orientation of one of the images so that you have the original and its mirror image.

2 Scan the Eiffel Tower and house images. Reverse the orientation of the images so they will transfer correctly. Size them to fit on the front of your transferred photo, as seen in the finished quilt.

3 Print all four images onto transfer paper. You may need more than one sheet.

4 Silhouette the portraits, leaving a hair's breadth of a border around the portrait cutouts. Cut the Eiffel Tower and house flush around their rectangular borders.

5 Iron all four transfers on the muslin, leaving ample space in between.

6 Cut the portraits from the muslin, leaving a generous ¹/₄" (6 mm) border all around for a seam allowance. Cut the Eiffel Tower and house from the muslin flush with their borders.

{ CELEBRATED CHEFS }
DEBBI'S TOP 5 INSPIRATIONAL PEOPLE

HENRI MATISSE His color choices were so shocking that he was dubbed a fauve (wild beast) by a French art critic. In his old age he became bedridden and nearly blind, but continued to work from his bed. I want to make art when I am an old lady.

FRIDA KAHLO She spent much of her life suffering, both physically and emotionally, but still created art with great passion.

MARC CHAGALL A country boy who went to the big city to become an artist. His rural upbringing is evident in his work. He reminds me that I don't have to be anybody but me.

DAN ESSIG The rare individual who can teach as well as he creates. His handcrafted books look like something in a dream, but I have held a few and know they are real.

MY DAUGHTERS, WHITLEY AND COURTNEY They are so strong and smart. I want to be just like them when I grow up.

how to CREATE THE INDIVIDUAL ELEMENTS

THE WINGED HEART

INGREDIENTS

Wing pattern on page 126

Two 10" (26 cm) fabric scraps, pink or red

Four 6" x 8" (15 x 21 cm) fabric scraps for wings

Fleece

Quilt batting

Sewing machine

Thread

Embroidery floss and needle

THE PORTRAITS

INGREDIENTS

Transferred photographs of the girl, houses, and Eiffel Tower

Remaining muslin and quilt batting

Sewing machine

Thread

Embroidery thread and needle

THE POEM

INGREDIENTS

Computer and printer

One sheet of cardstock

Colored pencil

Fold a large red or pink scrap in half. Pin the edges together. Draw a free-form heart and cut out, leaving about a ¹/₄" (6 mm) seam allowance. Keeping the right sides of the fabric together, pin the heart to a piece of fleece that is slightly larger. Stitch all around, leaving a small opening for turning. Cut the fleece even with the red fabric. Snip the curves. Turn right side out through the opening. Stitch the opening closed. Use the pattern on page 126 to create two wings in the same fashion as the heart. Cover the heart with a random sprinkling of French knots. Machine quilt some curvy lines onto the wings.

With the transfers face down, trace around the portraits on muslin and cut out. Pin to fleece and sew just like the heart. Cut shadows for the figures from scraps of darker fabric. Sew the portraits on top of the shadows using a running stitch.

Don't complete this step until you are ready to sew the poem onto the background. You'll lose it. Okay, I would lose it. Print out this poem or another onto the cardstock. Leave extra spaces between the words and lines. Draw a box around each word with colored pencil and cut out.

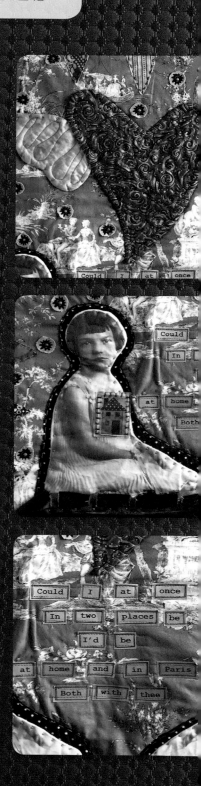

1 Place the front-side fabric face up and cover with the back-side fabric (shown above), face down. Top with fleece. Pin generously.

2 Sew around the perimeter with a ¼" (6 mm) seam allowance. Leave about a 6" (15 cm) opening for turning right side out. Clip corners and turn right side out. Handsew the opening closed.

3 Cut out a bunch of different sizes of isosceles triangles from the scrap fabric.

4 Place the triangles around three sides of the quilt base as the border. Experiment with placement, cutting special sizes to fit in the corners as needed.

5 When you are happy with the way the border looks, pin or lightly glue the triangles into place.

6 Handstitch around each triangle, through all the layers, using embroidery floss and a running stitch. You are appliquéing the triangles and quilting the piece all in one step. I call this "appliquilting."

how to MAKE THE QUILT BACK

INGREDIENTS

Two 24" (61 cm) squares of fabric, one for the front, one for the back

24" (61 cm) square of fleece or batting

Scrap fabric for triangles

Pins

Sewing machine

Needle and thread

Embroidery needle and floss

STUDIO SNACK

Tiger Butter

This is the closest thing I have to a family secret. You don't need a candy thermometer or double boiler, so it's perfect to make when you need to be in two places at once—the studio and the kitchen. I use it to bribe people, and it usually works.

1 24 oz. package of white dipping chocolate

1 small jar of smooth peanut butter

1 16 oz. bag of semi-sweet chocolate chips

1 Melt the white chocolate in a saucepan over very low heat, stirring frequently. Be careful not to scorch it.

2 Melt the semi-sweet chocolate chips in a separate pan, also over very low heat, stirring frequently.

3 When the white chocolate is melted, remove from heat and stir in the entire jar of peanut butter. Pour this mixture into a 9" x 13" pan.

4 Drizzle the melted chocolate chips over the top. Swirl with the tip of a sharp knife to make a marbled pattern. When it firms up, cut it into squares.

how to ADD THE CENTRAL ELEMENTS

INGREDIENTS

Needle and embroidery floss

Sewing machine

Scrap fabric for circular motifs

Beads

Buttons

24"(61 cm) satin ribbon

1 Arrange the portraits and other elements onto the front of the quilt as desired. Trust your judgment on what looks right. Glue or pin the elements in place.

2 "Appliquilt" each element. I used a combination of hand and machine stitching.

3 For another layer of interest, I cut circular motifs from printed scrap fabric and attached them using a single stitch through a bead. I scattered them over the bare areas of the quilt. Each is tied separately on the back of the quilt.

4 Using a craft knife and cutting mat, cut a series of slits along the lower edge of the quilt. Weave ribbon in and out to connect the two figures (this is my tribute to Frida Kahlo).

{ MAD FLAVA' }
how to add your signature style

Each project in this book is an exercise in developing your own signature style. Here are more ideas to help you develop it.

✧ Study the character of the doodles you draw while talking on the phone or sitting in meetings to see what marks you like to make. What you mindlessly draw when you are not thinking about art tells you a great deal about your personal style.

✧ Is there an era of fashion you are drawn to? Do you prefer paisley, Pucci prints, or boho chic? Incorporate patterns and embellishments you find appealing in fashion into your artwork.

✧ Look around your house. When I think about my favorite colors, yellow does not immediately come to mind. But if I look around our home, almost every room is painted some flavor of yellow. Your signature style emerges without you even noticing!

✧ Like hem lengths, trends in mixed media come and go. If you like what everybody else is doing, and it feels right to you, do it. If you don't like the trend, pass on it. People will respond to the authenticity of the sentiment expressed in your work more than to the particular colors or images you use to express it.

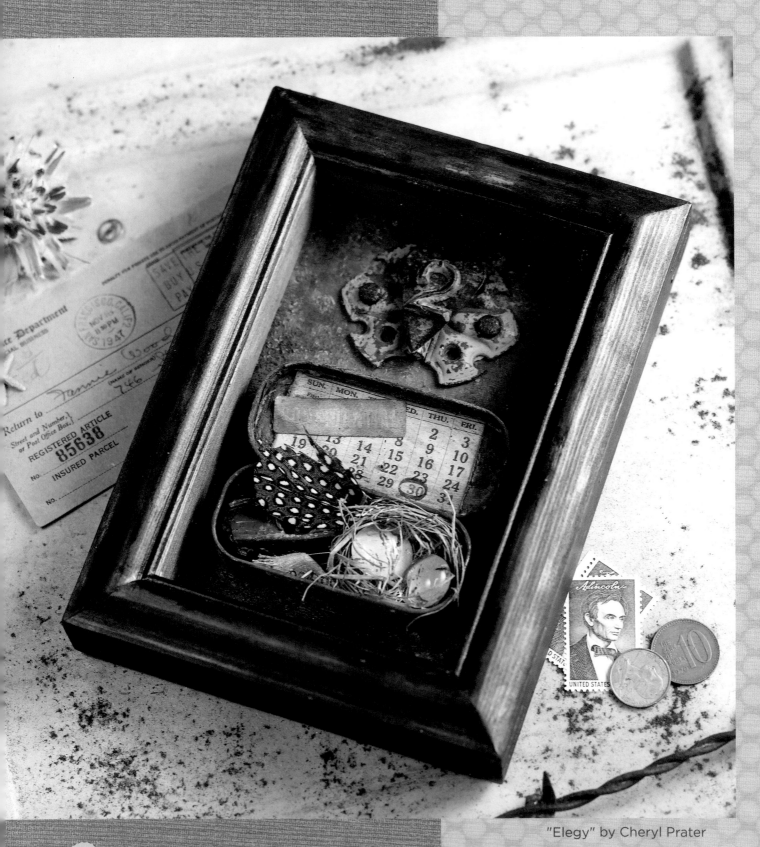

"Elegy" by Cheryl Prater

{ TWO COOKS IN THE KITCHEN }
WHAT IS "MIXED MEDIA"?

C: Debbi, how many mixed-media artists does it take to screw in a light bulb?

D: I don't know.

C: Five. One to scour flea markets for the perfect vintage light bulb, one to collage over it with found papers, one to age it further with walnut crystals, one to give it nice highlights with Treasure Gold rub-ons, and one to stick it in the socket with E6000 heavy-duty adhesive. It doesn't work, but it looks wonderful, and sells on Etsy.com for $45.

D: I should probably mention that I hate the phrase mixed-media artist. I think it has become overused to the point that it doesn't mean anything anymore.

C: So, you're not a mixed-media artist?

D: No, I'm not sayin' I ain't one, just that I don't like the words. I'm a mixed-media artist because it seems to take a lot of stuff to tell my story, and I don't like to limit myself.

C: I hear that! "Mixed-media artist" isn't a label I gave myself, more like one that was given to me—along with lots of other labels that don't need to be mentioned here. Admittedly, I have a short attention span. I am interested in a lot of diverse things (for example, I like Jane Austen and "The Terminator"). I want to try everything at the creative tasting party. Mixed media is all inclusive: when I tire of collage I can add in paint; when I'm sick of that I can sew or solder. I can change gears and materials but never change my moniker.

D: Art has always been part of my life. I didn't have a big mixed-media revelation in 2003 and declare myself an artist. The only way art could change me is if I stopped making it. That will happen right after pigs fly while I'm wearing a Tom Brady jersey and taking one my girls to Purdue University.

C: I love going into my studio feeling like I want to make something, not knowing what I will do, and coming out hours later with a painting or a collage or assemblage. I love the options and variety.

D: Art just makes life more fun—better living through mixed media.

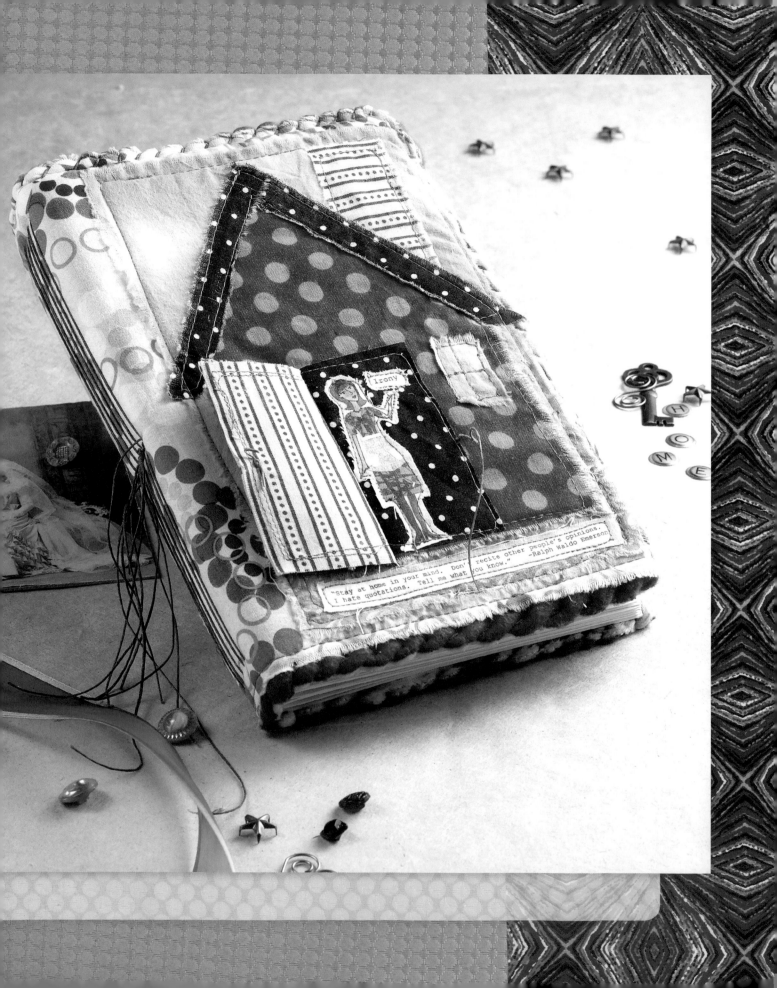

DEBBI'S FABRIC JOURNAL
{ HOME COOKIN' IS ALWAYS BETTER THAN FAST FOOD }

"STAY AT HOME IN YOUR MIND. DON'T RECITE OTHER PEOPLE'S OPINIONS. I HATE QUOTATIONS. TELL ME WHAT YOU KNOW."
—RALPH WALDO EMERSON

THERE IS VALUE IN MAKING SOMETHING YOURSELF, JUST THE WAY YOU LIKE IT, AND NOT SETTLING FOR WHAT IS COMMERCIALLY AVAILABLE.

I have used many sketchbooks in my lifetime of art making. Until 2003, all of them were of the store-bought ready-made variety. I made my first sketchbook that summer, after learning the Ethiopian Coptic binding from Dan Essig. Choosing the color and texture of the paper and the material for the cover made the book personal and mine before I ever made a mark in it. Its style shows my MO as an artist: I don't believe in making art about misery. There's enough bad in the world. I want art to uplift, enlighten, educate, and be sweet.

That first sketchbook was quite precious to me because I used very expensive handmade paper for the pages and cover. It's a beautiful book, but there are still blank pages in it. I was cautious about the drawings I made in it because I didn't want to waste the pages. I have abandoned that sketchbook in favor of simpler books made with less expensive materials. This fabric journal was designed to suit my need for a sturdy, yet cool-looking book that is so easy to make I won't feel guilty about filling it up.

This book opens completely flat, so it's easy to write, draw, or paint all the way down to the spine. This technique can be applied to any other size you would like to make as well. Take care in cutting the paper for uniform pages and a nice finished look. The one specialized item you will need to create a durable book is waxed-linen thread. Look for it in your local art supply store, or see our list of Resources on page 125.

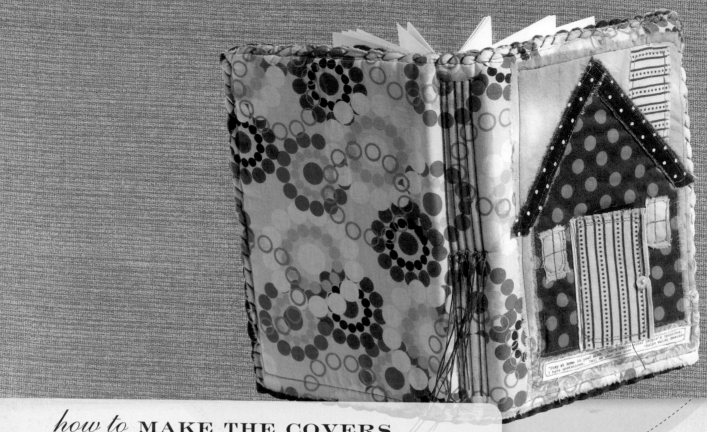

how to MAKE THE COVERS

INGREDIENTS

Two 8 ½" x 13" (22 x 33 cm) pieces of cotton fabric, may be the same or different

Two 9" x 13 ½" (23 x 35 cm) pieces of polar fleece fabric, same or different

Two 5 ½" x 8 ½" (14 x 22 cm) pieces of chipboard or mat board*

Two 1" x 8 ½" (2.5 x 22 cm) pieces of chipboard for spines

Fabric scraps

Sewing machine or handsewing needle and thread

Embroidery needle and floss

Two copies of the spine pattern (p. 126)

House pattern (p. 126) (optional)

Screw punch

* If you don't have chipboard, use some hard covers from a cast off textbook or library book. They work great for this.

1 Cut out the photocopied spine patterns and use them as guides to create two spines from chipboard. Then, glue the templates to each of the chipboard spines and allow the glue to dry. If you prefer a glue stick, you may use that instead of the white glue. It will dry faster and probably hold long enough for you to get the holes poked in the sewing stations. Sewing stations are the points at which you will sew through the spine to create the binding. Use your screw punch to create the holes, which you will stitch through later (see image above right).

2 Using the tiniest touches of white glue—it is NOT mayonnaise and you do NOT work at Subway—glue the chipboard covers and one spine to one piece of the polar fleece, leaving a board's width of space between the covers and spine. This will allow the book to close. Set the additional spine aside for later. Top with the other piece of fleece. To make sure that the orientation of the book stays constant throughout its creation, use a marker to redraw the arrow on the spine on the fleece (see image above right).

3 Now you can get fun and creative: Make the artwork for the front cover. You can use the pattern on page 126 to

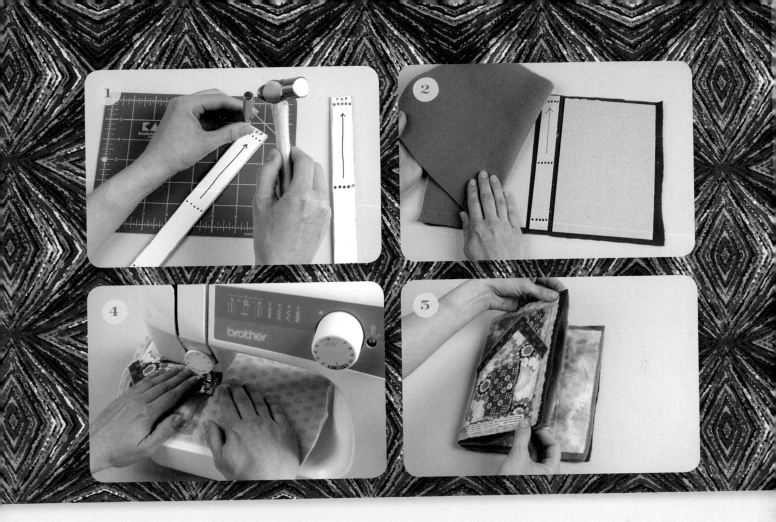

create the house that is shown on my book, or anything goes. The only concern, if you choose to be concerned, is durability. Theoretically, books have covers to protect the inside, so the cover will take the brunt of daily wear and tear. Your journal might wind up in the bottom of your bag or under your car seat—have you looked in either of those places lately? In other words, a paper doily is probably not the best adornment for a journal cover; fabric and stitching is more like it. Begin with a fabric base about 8" x 5" (21 x 13 cm) and then use fabric scraps to create a collage. And then, ooh, what about transferring a piece of your existing artwork onto fabric and adding that? This book features one of the paper dolls from pages 16–19. It was scanned and printed onto fabric transfer paper (see page 64 for transfer technique). A bit of embroidery is a nice touch, too.

4 Upon completion of the cover artwork, hand or machine stitch it to the right-hand end of the cotton fabric that you are using for the exterior cover, leaving about a $^1/_4$" (6 mm) seam allowance on the top, bottom, and end (see image above). Make

sure you are sewing the artwork to the front cover, not the back.

5 Grab the additional piece of cotton fabric to use as the interior lining of the cover. Lightly glue the cotton fabric to the fleece-covered chipboard spine and cover. Keep the arrow you drew on the fleece pointing up. Stop and think about logistics for a moment: you want to make sure the cover artwork you just created will actually wind up on the cover, right side up, when the book is closed. The fleece will peek out about a $^1/_4$" (6 mm) all around (see image above).

6 Use six strands of embroidery floss to whipstitch around the entire edge of the covers and spine. This will hold all the layers together.

how to MAKE THE PAGES

INGREDIENTS

20 pieces of cardstock or paper*

Awl

Ruler and pencil

Scrap cardboard

Spine template (page 126)

* I prefer cardstock because it holds up under any media, wet or dry, I decide to use in my journal.

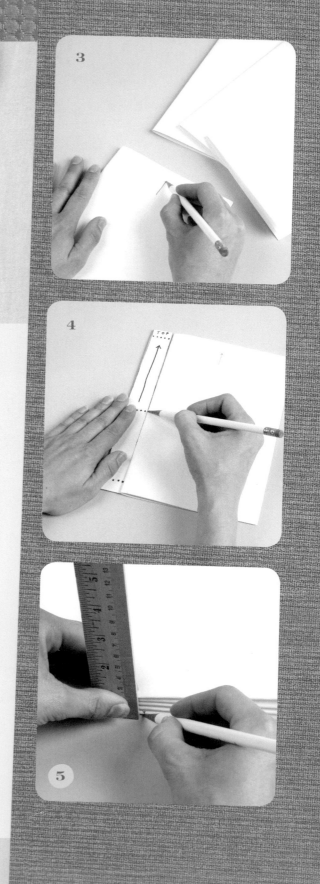

1 Gather your cardstock to create your pages. Keep in mind that the pages don't have to be white. Consider using colorful cardstock or an assortment of different papers from the stash you have on hand.

2 Group the sheets of cardstock into five sets of four pages each. Fold each set in half. These are the five signatures (this is the bookbinding term for "group of pages") you will sew into the spine.

3 Use a pencil to lightly draw a small arrow pointing up on the front of each signature, which will help insure that the signatures open from the left (see image right).

4 Place one signature beside the extra spine template, lining up the arrows to point the same way. Mark the fold of the signature at each one of the three sewing holes on the template (see image right).

5 Keep this signature on the table and top it with the other four, making sure all of the arrows are pointing the same way. Align a ruler to the spines of the signatures (see image right). Locate the marks you made on the spine of the first signature and use a pencil to draw a line up from it along the spines of the rest of the signatures. (Note: you may or may not want to number the pages inside the signatures at this time. If you number them, keep in mind that you will need to keep them in order throughout the duration of the project.)

6 Open each marked signature over a stack of cardboard. Use the awl to punch the sewing stations (holes) at the marks.

how to SEW THE BINDING

INGREDIENTS

Spine template (page 126)

10′ (3 m) waxed-linen thread

Embroidery needle

1 small clip

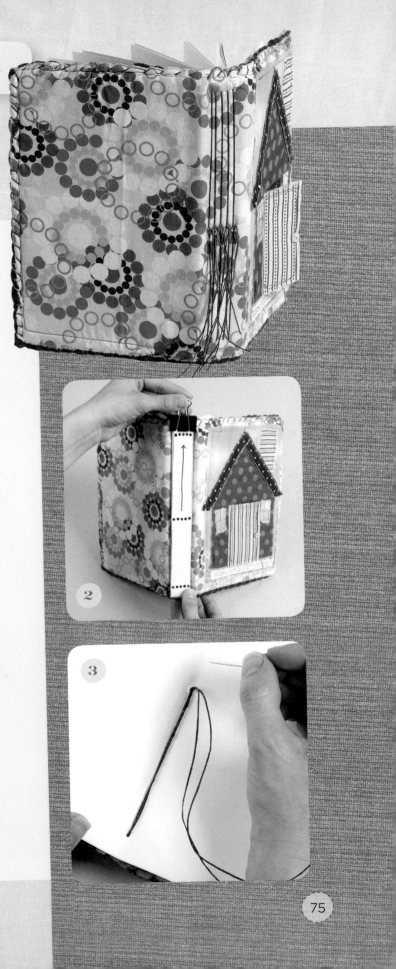

1 This journal is bound with the simplest and most versatile of all binding stitches—the pamphlet stitch. The book will open completely flat at any page, without any break-in period. Thread an embroidery needle with about 5′ (1.5 m) of waxed-linen thread. It will take more than that to bind the entire book, but it is difficult to work with too much at a time.

2 It's time to grab the additional spine because it's going to make sewing waaaay easier. Use the clip to hold the extra spine in place on the outside of the cover over the spine hidden in the fabric, arrow pointing up and top edges aligned (see image right).

3 Place the first signature inside the cover using the extra spine as a guide (be sure the arrow on the front of the signature is pointing up). Sew up through the first center sewing station on the spine and through the center station in the first signature (don't sew through the extra spine). Leave about a 5″ (13 cm) tail outside (see image right).

4 From inside the center station, sew down through the top station to the outside of the spine. Remove the template.

5 The next stitch goes all the way down to the bottom station on the outside of the spine. You will have to feel around with your needle to find the station. Sew into the spine to the inside of the signature.

6 To finish sewing in the signature, sew back out the center station, to the outside of the spine. Place a thread on each side of the long center stitch, cut to about 5″ (13 cm), and tie into a square knot over the long stitch. Repeat with the four remaining signatures. Place beads or charms on the waxed-linen thread tails for a little book jewelry.

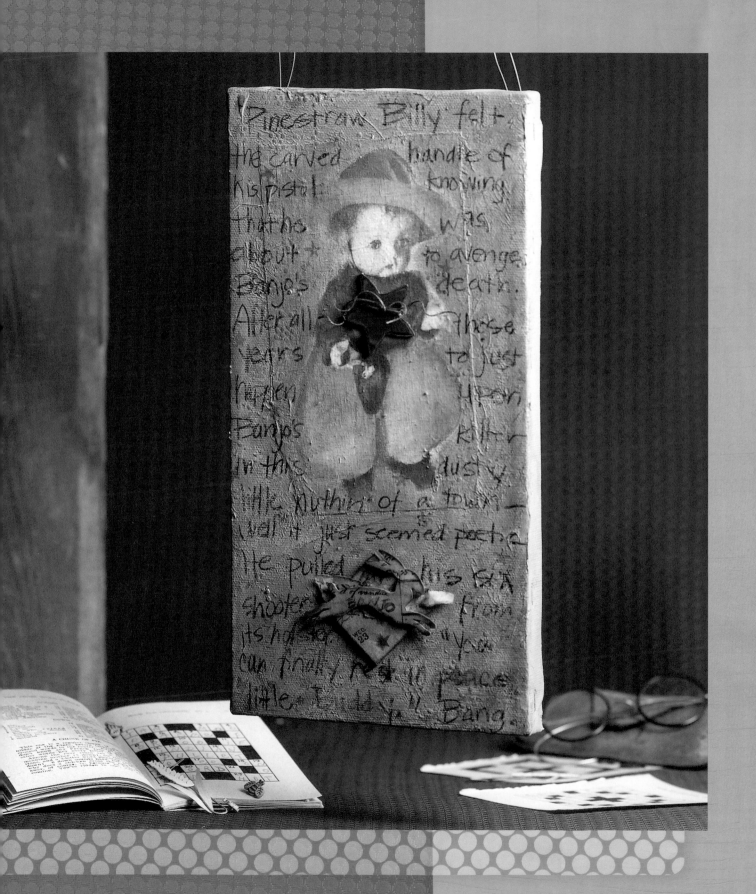

CHERYL'S DIMENSIONAL COLLAGE
{ FEED THE NEED FOR TEXTURE }

> "I DO NOT SEE ANY BEAUTY IN SELF-RESTRAINT."
> —MARY MACLANE

IF A LITTLE BIT IS GOOD, THEN A LOT MUST BE FABULOUS.

Once you embrace this philosophy, it will go a long way to explain the way I approach collage, frost a cake, or apply make up. In fact, I use the same spackle knife for all three purposes.

Sometimes more is more, and when I'm collaging, this tenet holds true. So how do you know when you're done, you ask? When is enough is enough? That's subjective; it's done when it feels done, when it looks resolved and finished to you. I usually know when something is done, but sometimes I am faced with the feeling that I need more but am not sure what to add. When this happens it might be good to walk away from it and let it ferment. Good advice, but taking a thoughtful pause requires patience, so instead you can just ask the opinion of someone whose artistic eye you respect for guidance.

This was the case with *Banjo's Revenge* (see left). Despite the layers and colors and embellishments and text, it felt like it wanted something. Enter a quick e-mail with a photo attachment to Debbi. She put her finger on it immediately and suggested stamping the little red stars randomly through the text—perfect! What a team.

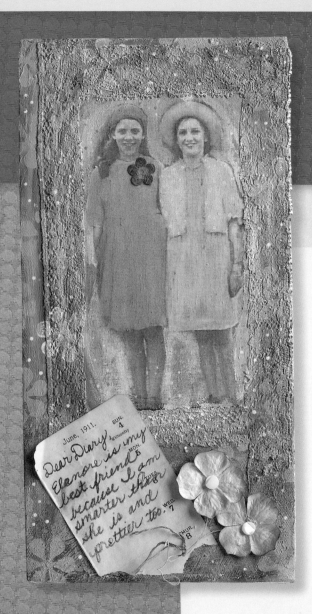

INGREDIENTS

1 sheet of stabilized fabric, compatible with your printer

Old family photo or copyright-free image

Printer and scanner

Iron

12" x 6" (31 x 15 cm) canvas (you could use any size, but I bought these on close-out)

Golden Matte gel medium

1 Choose a black-and-white image you'd like to collage, and scan it into your computer. Print it out on the stabilized fabric to a size that will fit on the canvas (see page 58 for stabilizing instructions). Yeah, you could use a paper printout for the image, but printing it on fabric gives it another layer of dimension, more texture, and a soft-grain image that paper will not.

2 Press the printed fabric with a hot iron to heat set the ink.

3 Make a rough cut around the image—you don't need a perfect silhouette.

4 Using a small piece of mat board—a 2" (5 cm) square is perfect—skim the gel medium over the entire surface of the canvas. It should be no more than 1/8" (3 mm) thick.

5 Place the image right side up on the sticky canvas where you want it.

6 Gently press the fabric image into the gel medium, walking your fingers around the edges to ensure it's stuck down. You can roll over it with a small brayer if you like, but be careful not to pick up gel medium from the canvas and roll back over the image. (If you get some gel medium on the image, don't panic; it's not catastrophic. But the gel medium will act as a resist when you go to color/ or paint the image with the water-soluble crayons. Heck, you might like the effect.)

7 The two cursed words: Let dry. Keep your heat gun handy and fire insurance current so you can get on to the fun part.

how to ADD COLOR AND TEXTURE

INGREDIENTS

Acrylic paint

Caran d'Ache water-soluble crayons

Dye-based inkpads by Ranger

Stencil for texture (a rubber stamp would also work)

Plastic wrap

Waxed-linen thread

Small brayer (optional)

Heat gun for Type-A impatient sorts

Stabilo pencil (optional and only needed if you want to write on your collage)

Gel medium

Gesso

1 Choose a color of acrylic paint and apply a base coat to the background. Paint the surface and sides of the canvas and around the image using the paint to silhouette the image and blend it into the background.

2 Again with the drying. Heat gun, stat. .

3 Apply some gel medium over the now dry painted area with the mat board scrap, avoiding the image. You can skim it on a little heavier this time, but the thicker you lay it on the longer it will take to dry. You may prefer to build up gradually for this reason.

4 Press some textures into the wet gel medium, such as rubber stamps or lace, or blot it with balled up plastic wrap, anything that will make the surface irregular and lend texture. It will be subtle (how novel, subtlety!) but don't worry, you're going to fix that by painting over it, making the wonderful designs in the gel medium evident.

5 While your textured layer of gel medium is drying, use water-soluble crayons to color in the subjects of your collage.

6 Wet a paintbrush in water, dab it in some gesso, then back in the water, creating a diluted gesso on your brush. Drag your brush across the lip of your water cup so it's not sopping wet. Paint over the colored areas of the image with the watered-down gesso.

7 Let it dry naturally (if you have time to brutally murder and the humidity index is low) or pull out the heat gun.

8 Repeat until you have the desired color intensity on your image.

1 Now that the textured gel medium is dry, you can add paint on top. Choose two colors that contrast with your base color, brushing them on, blending them together in some places and then wiping them off with a damp paper towel and/or blotting in spots to allow the base color to show through.

2 Annie getch yer heat gun. You got a permit for that thing?

3 Depending on the result, you may want to add another layer of textured gel medium; three textured coats is the standard around here. If you want more-more-more, repeat the texturizing and painting process until you are happy with the results. Now that the image is colored, feel free to add gel medium over it. This really blends the image with the rest of the canvas.

4 Distressing inks are a great complement to acrylic paints. You can rub the pads directly on the dry painted/textured areas—the ink hits and highlights the raised areas, making them more visible. Some brands of distressing inks stay wet a bit longer than conventional dye inks, so you can blot them, spread them, mix them by overlapping colors, and dilute them with water once they are applied. Play with it. There's no right or wrong way to do it.

5 Tedious, this drying.

6 Once you are satisfied with the result, embellish your collage with writing, glitter, ribbon, and bits o' junk.

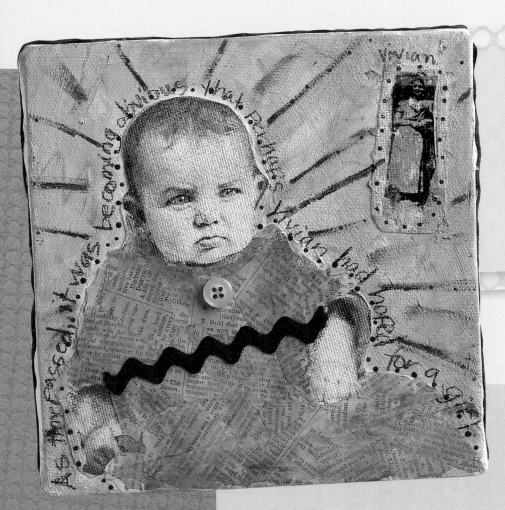

INGREDIENTS

Acrylic paint

Gel medium

Distress Inks by Ranger

Texturizing items

Heat gun

Embellishments

Thea Betsy's Spanikopita

Are you surprised I like food with lots of layers? Enjoy this recipe for Greek Spinach Pie, courtesy of my aunt, Betsy Karounos. Betsy is also a multi-talented artist who contributed to our gallery on page 123.

1 4 oz. container of crumbled feta cheese
1 10 oz. package of fresh baby spinach (I get pre-washed)
1 egg
½ stick butter, melted, with ¼ cup olive oil added
Some grated parmesan or romano cheese
1 package phyllo (in the freezer aisle with pastries)
olive oil
1 clove of garlic, minced
1 medium onion, chopped
salt
pepper
oregano
dill

1. Over medium-low heat, put two to three tablespoons of olive oil in a large frying pan. Add the onion and garlic and sauté until the onion becomes translucent. Add the spinach—it will mound up in the pan but cooks down, so don't panic. Add about a teaspoon of salt (not too much because feta is very salty) and about a teaspoon of oregano and a ½ teaspoon of dill. Stir as the spinach cooks down.

2. When the spinach is cooked all the way down and dark green, remove the frying pan from the heat and tip it so the oil and water drain off to one side. I blot it up with a paper towel and even blot the spinach a bit to get all the extra moisture out.

3. In a small bowl, slightly beat the egg and add to the crumbled feta. Add one or two tablespoons of the grated parmesan or romano. Mix the cheese in with the spinach in the frying pan. Set aside.

4. Using a basting brush, coat a glass pie plate with the melted butter/oil mixture. Next lay one sheet of phyllo in the plate (you will have excess hanging over the edges, don't worry we'll deal with that later). Brush that sheet with the butter/oil and lay another sheet on top. Do this until you have 10 to 12 sheets in your pan. This is the bottom crust. Scoop the spinach mixture into the crust, and top with a sheet of phyllo. Create the top crust with remaining phyllo, brushing each layer with the butter/oil mixture.

5. To finish, here's my mom's advice, straight from the recipe card: "You can trim off the excess phyllo if you like. I fold it in along the edges and baste it with the butter/oil. Turns out nice and crunchy. Bake at 350 degrees until golden on top. Looks like a lot but it goes fast. Have fun—love, Mom."

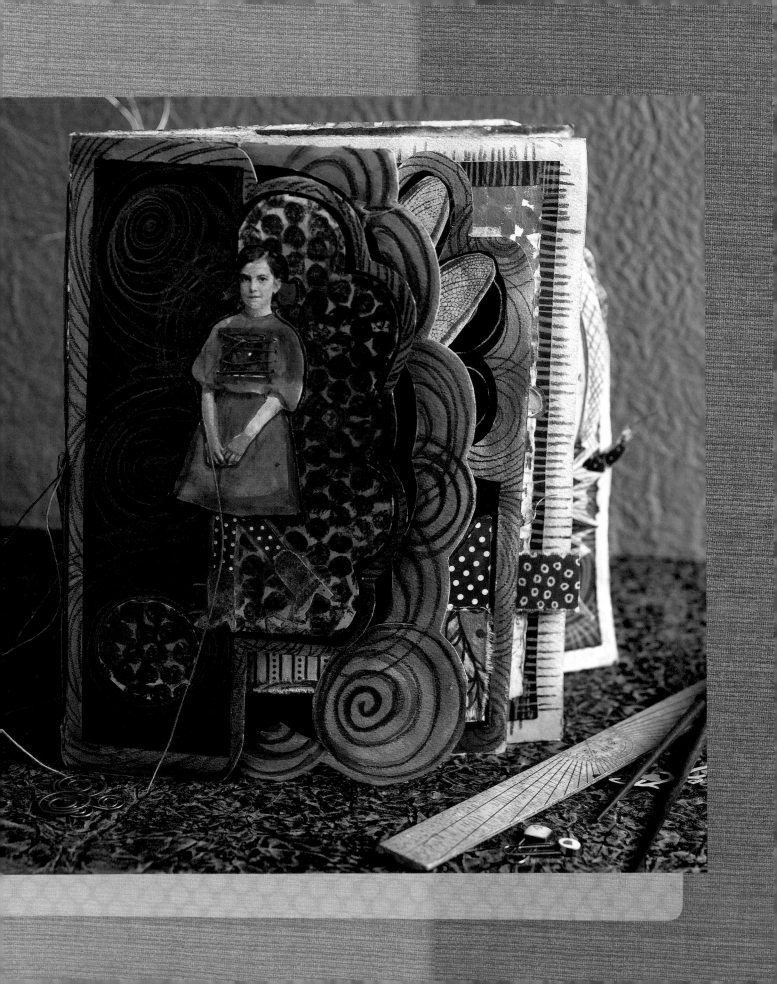

DEBBI'S PEEK-A-BOO COLLAGE BOOK

{ LAYERS—NOT JUST FOR CAKES ANYMORE }

> "I'D RATHER NOT SING THAN SING QUIET."
> —JANIS JOPLIN

IF YOU'VE NEVER MADE A BOOK BEFORE, THE PEEK-A-BOO COLLAGE BOOK IS A GOOD PLACE TO START.

There are only seven spreads, plus a cover, so it is a manageable enough size to actually finish. But that's the challenge of this project: finishing.

This project will require much of your soul. For several years, I was quite content with making blank books. These books were not journals or sketchbooks; instead, they were monuments to a new binding I had mastered. One work I created over a week's worth of time. The covers are mahogany, patterned with multiple layers of paint applied with great care. It is bound with a difficult stitch and filled with lovely, creamy pages. One of my second-grade students examined this perfect book one day, taking in every detail. He told me it was pretty good, but it needed some writing in it.

I admit to being a little offended, but a few years later, my thinking caught up to the eight-year-old's. The artist's books I now create are a perfect marriage of text and image, content and structure. I have made far fewer of these books than blank books. I have to think about the overall theme of the book, what each page will look like and how each page will relate to all of the other pages.

When you commit to making such a book, you have to persevere through the ugly. When I think back to the first such book I made, I am grateful for it taught me to use ALL the colors, ALL the patterns, ALL the stuff.

If you let it, this book will set you free, free to use color on top of color, pattern on top of pattern. You are free to use any theme, any size, any thing. The result will be a book that invites the viewer in, with each page peeking out from the one before. The key is to make the book about something you love, and you'll have no problem filling the pages.

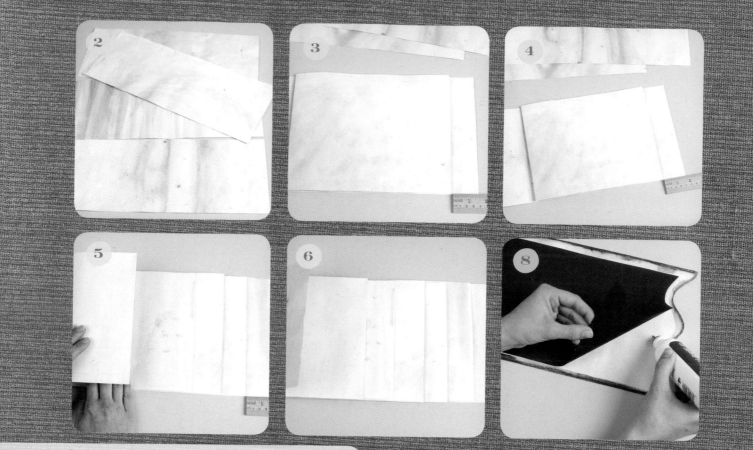

how to MAKE THE BOOK

INGREDIENTS

1 sheet of watercolor paper*

Enough black paper to cover both sides of the watercolor paper**

Collage papers (commercially printed or your own)

Newspaper or other scrap

Alphabet stamps and inkpad or word-processed text

Caran d'Ache water-soluble crayons

Walnut ink

Dry-mount adhesive sheets (optional)

* I usually use 22" x 30" (56 x 76 cm), but any size is fine. The larger the paper, the larger the book will be.

** I like Canson Mi-Tientes for this, but cardstock would also work.

1 Dye both sides of the watercolor paper with walnut ink, allowing the ink to dry between applications. Be sure to cover the entire sheet and both sides.

2 Cut the watercolor paper in half width-wise. Cut each of those in half width-wise again, so you have four pieces that each measure 22" x 7 ½" (56 x 19 cm) if you began with a 22" x 30" (56 x 76 cm) sheet. (Whatever size paper you began with, cut it into four equal parts.) Number the sheets lightly with a pencil: sheet 1, sheet 2, etc. (see image above).

3 Fold sheet 1 exactly in half. Lay sheet 1 on top of sheet 2, matching up the open edge of sheet 2 with the right-hand edge of sheet 1 (see image above).

4 Scoot sheet 1 back from the edge of sheet 2 about 1 ½" (4 cm). Fold the left-hand end of sheet 2 over sheet 1 (see image above).

5 Lay sheets 1 and 2 in their folded state on top of sheet 3, matching up the long right edge of sheet 2 with the right edge of sheet 3. Scoot sheets 1 and 2 back from the edge of sheet 3 about 1 ½" (4 cm). Fold the left-hand end of sheet 3 over sheets 1 and 2 (see image above).

6 Lay sheets 1, 2, and 3 in their folded state on top of sheet 4. Scoot and fold as you did in steps 4 and 5. Moving the fold for each sheet is what creates the staggered edges of the pages and this book's unique look (see image above).

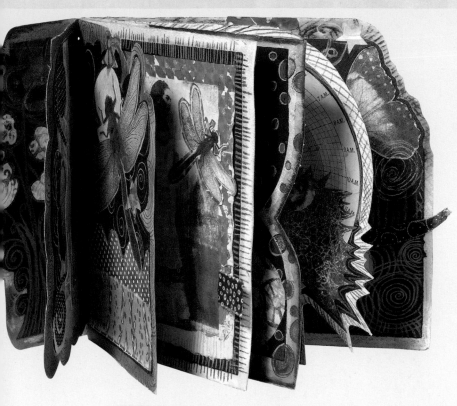

STUDIO SNACK

The Cheeseball of My Childhood

Yes, I grew up in the 1970s. This will tide your husband and kids over until you're at a good stopping point and can make a real dinner.

1 jar of Roka Blue cheese spread

1 jar of Old English cheese spread

1 package softened cream cheese

2–3 tbsp. minced onion

1 tbsp. Worcestershire sauce

1 cup chopped pecans

Ritz crackers

Combine the cheeses, onion, and Worcestershire. Form into a ball and roll in pecans. Chill to firm. Serve with Ritz crackers.

7 The fore edge of each page is ready to be shaped. The center pages created from sheet 1 are exactly the same size, so you may choose to cut a shape that is symmetrical, such as a butterfly. I like to keep the book assembled, sketch proposed cutting lines in pencil, and then cut them one at a time, reassembling the book after each cut so I can evaluate how the cuts look together. The most important thing about cutting the edges is this: do not cut within an inch on each side of the center crease. If the center creases do not remain intact, you will not be able to bind the book.

8 Now it's time to add color to the fore edge of each page. This is a messy job, so place each of the four sheets on its own sheet of newspaper. Make sure the newspaper is visible on all sides. Use the water-soluble crayons to draw a thick outline around each sheet of your book. Be careful not to move the sheet around on the newspaper, which will help keep the opposite side of the paper clean. Use a small brush dipped in clean water to blend the crayon outlines. Allow it to dry. Flip the sheets over onto clean sheets of newspaper and repeat the process on the other side. When all the outlines are dry, trace each sheet twice onto the black paper. Cut out the black shapes about a ¼" (6 mm) inside the outline. Adhere the shapes to the pages with dry-mount adhesive sheets or white glue (see image left).

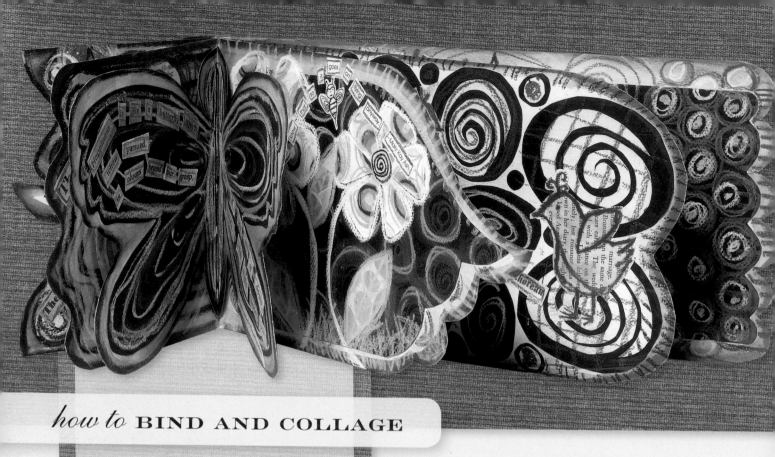

how to BIND AND COLLAGE

INGREDIENTS

Paper drill or awl

Craft knife and cutting mat

1 yd (0.91 m) waxed-linen thread

Word-processed text or quotes

Watercolor paints

Colored pencils

Collage images

Collage papers

Dry-mount adhesive sheets

Caran d'Ache water-soluble crayons

1 We're going to bind the book with a pamphlet stitch (see page 75 for instructions). Assemble the book in order and open flat over your cutting mat. Use the paper drill to make three holes directly on the center crease: one should be ½" (1.3 cm) from the top, one in the center, and one ½" (1.3 cm) from the bottom.

2 Now you are ready to collage (woo hoo!). Perhaps you had an idea for the content of this book when you started and your head is already full of words and pictures. Or maybe you thought you'd try making the book itself and then figure out what to put in it. If you are of the latter persuasion, don't panic or hide the empty book in a plastic tote in your craft room. Go directly to the computer, get yourself on the Internet, Google "quotations," and you are in business. Search the site for quotations concerning a particular topic or key word, like family, flight, or freedom. Find a few quotes that resonate with you and, ta-da, there is the text for your book. Be sure to properly attribute the quote to its author. To make the text a little more personal, intersperse your own commentary with the quotes.

3 Type the text in a font that complements the theme and style, making sure to add extra spaces between the words. After I printed my text, I painted over the words with a light coat of watercolor, allowed it to dry, and outlined each word with colored pencil.

4 Now, choose the imagery. For the book on flying, I made collages of birds, wings, dragonflies, and bees, cutting images out of a combination of my crazy papers and commercially printed papers. Sometimes I draw the images in my books; other times I use photocopied pictures or rubber stamps. When I have decided on the main image for each page, I love to add concentric circles and curlicues to the mix.

5 To really simplify the collage process, consider using dry-mount adhesive sheets (used in framing) instead of glue. Apply a sheet of patterned paper to one side of the adhesive sheet and cut out your image. When you are ready to adhere the image to the page, peel off the backing to reveal the sticky side and apply your image.

6 Gather all of your elements—text, images, and extras—and start forming the pages. Use all of your elements or only some. Finish pages before moving onto the next or work on them all at once. Save the text for last so that you can integrate it into the imagery.

7 Add the finishing touches with the water-soluble crayons, making marks around the edges of each page and within the individual collages. If you leave the marks as they are, they will look more rustic than if you blend the colors with water.

{ 30-MINUTE MEALS }
daily art projects are a great way to feed yourself . . .

Near the end of 2003, I decided to have a daily art goal for 2004. In the ensuing twelve months, I made a miniature book, styled to look like a tiny purse, every single day. Wow! I always had a few minutes to make art, even with a full-time job, a full-time husband, and two high-octane kids. It was like cooking dinner. Some nights it's fancy; some nights it's plain. But no matter, everybody gets fed.

I hope you will use the ideas below to inspire daily art in your own life. Whatever project you choose to do, it will serve as a diary of the year, even if you don't write any words on it.

2004 — THE YEAR OF THE PURSE BOOK This first year taught me not to make excuses. I took it like the vows: in sickness and in health, for richer or poorer, the whole routine.

2005 — THE FAT LEATHER JOURNAL I made a leather journal with twelve chapters, one for each month, and added to it every day. I did not account for the extra thickness all the collaged materials would add to the pages. Just like the Supercenter, it never closes.

2006 — PAPER DOLLS I started making a doll every day from a free downloaded template, but soon began to create my own dolls from scraps and photographs. I kept the template as a fall-back position, for days when I didn't have a good idea. Lesson learned: You don't have to create a masterpiece every day; you just have to create every day.

2007 — THE GIANT JOURNAL I loved the dolls, but I kept scattering them out, and I was afraid I would lose one. I wanted to go back to a journal to keep the whole year's work together. At least I thought I did. By October, I referred to the 2007 project as Journal Jail. The book was huge, about 12"W x 14"H x 3"D (31W x 36H x 80D cm), and heavy and a pain to drag around with me. I learned that I need something that is portable.

2008 — LITTLE QUILTS I am making a 6" (15 cm) square quilt every week, adding a little something to one every single day. I wanted to do something in fabric, and even I could figure out that a quilt a day was an insane challenge. The 6" (15 cm) size is manageable and portable, and I think I can keep track of fifty-two of them.

FUTURE PROJECTS

I am forever planning, so it should be no surprise (especially to Cheryl), that I have a few ideas for daily art projects in the years to come.

- What's black and white and red all over? An art journal I'd like to make one day. I think this daily challenge will succeed because it has such clearly defined parameters. Limiting color choices will help me to focus. This journal would also get me back to drawing, which I love, but neglect, like my Kitchen Aid stand mixer.

- When my girls grow up and leave me, I might get lonely. Maybe I need fifty-two little friends to keep me company. I have toyed with the idea of making one art doll every week for a year. They could be made of fabric or found objects and could be any size.

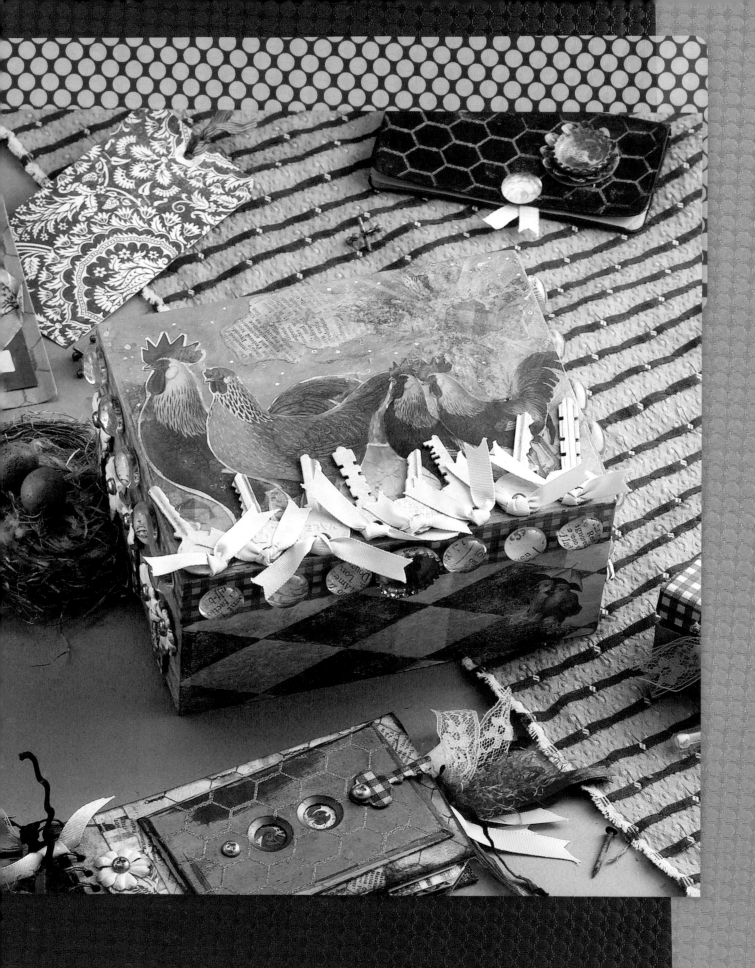

CHERYL'S KEEPSAKE BOX
{ GO AHEAD, PUT YOUR EGGS IN ONE BASKET }

"HELLO, CHICKENS."
—CAROL PRATER

THIS TREASURE BOX HOLDS LITTLE "COOPSAKES" OF OUR CHICKENS FOR US TO ENJOY LONG AFTER THEY LEAVE THE NEST.

I suppose it was because they weighed less than three pounds apiece and resembled little birds that my mother-in-law nicknamed her newborn grandsons "the chickens." This term of endearment suited them and it stuck, so it seemed appropriate that a treasure box to hold souvenirs of the boys' fleeting childhood be adorned with their barnyard namesakes.

This project mixes store-bought items with junk and found objects that lend personality and a sense of history. The top of the lid is collaged with our family's poultry counterparts strutting along a white picket fence of keys tied with green ribbon grass. Flowers with decoupaged key stems are growing around the outside of the box under a border of flat marbles reflecting bits of text and imagery like tiny gazing balls.

Inside there's a tag book for writing down the funny things the boys say and do that I swear I'll remember but too often forget, a tiny box for baby teeth and curls of hair, an envelope, and a small diary for storing favorite photos and notes.

Although I chose a lot of busy patterned papers, they are unified by color. The tissue papers decorating the box were mostly white with a red pattern. After adhering them with decoupage medium, I washed the tissues with acrylic paint to change the white portions to blue or green.

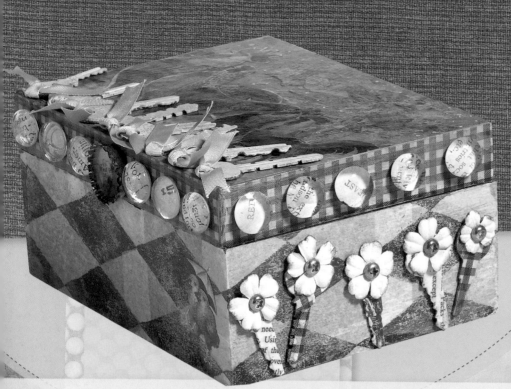

how to MAKE THE BOX

INGREDIENTS

Hinged wooden box approximately 8" x 5" x 3" (21 x 13 x 8 cm) high

Anna Griffin Roosters & Hens decoupage paper packs by Royal Coat*

4³/₄" (12 cm) Cabernet Toile & Woodland Decoupage Tissue Pack by DMD Paper Reflections

Text-patterned papers

Mod Podge decoupage medium by Plaid Enterprises

Gold acrylic paint

Caran d'Ache water-soluble crayons

Gesso

Blue-green acrylic paint

* All of the chickens except the baby chick with the umbrella came from this pack. The baby chick was scanned from a vintage postcard image.

1 Paint the box inside and out with gold acrylic paint. Find a wrinkle in the space-time continuum and travel forward to a point in time when the paint is dry.

2 Collage background papers onto the lid using pieces of the patterned tissues, vintage text, and decoupage papers. Arrange them on the surface and then apply a coat of decoupage medium. Use the water-soluble crayons to enhance the clouds and sun while the decoupage medium is still tacky.

3 Silhouette cut the chickens and roosters from the patterned paper and decoupage them onto the background.

4 Brush eight keys with gesso. Once dry, thread each with green grosgrain ribbon and tie in a knot. Glue the keys to the lid with heavy-duty adhesive to make the fence.

5 Decoupage the red gingham tissue to the sides of the lid. No need to precut it—just coat the edge of the lid with decoupage medium, lay the tissue over the top, and smooth it with your finger. Trim or tear away the excess.

6 When the decoupage medium is almost dry, brush on blue-green acrylic paint over the tissue and immediately wipe the paint off, leaving only a color wash that tints the white portions.

7 Repeat steps 5 and 6 for the sides of the box with the harlequin patterned tissue. You may have to overlay sheets to match up the patterns.

how to MAKE THE BOX EMBELLISHMENTS

INGREDIENTS

Flat glass marbles

Keys

Bottle cap

Eyelet paper flowers

4³/₄" (12 cm) Cabernet Toile & Woodland decoupage tissue

Patterned papers

Text-patterned papers

Watercolor paints

Gold acrylic paint

Lime-green and maroon chalk ink

Mod Podge decoupage medium

Diamond Glaze dimension medium

E6000 heavy-duty adhesive

¹/₂" (1.3 cm) and 1" (2.5 cm) circle punch

1 **COLLAGED FLAT MARBLES** Use your watercolor paints to wash over the text or patterned paper you'd like to show through the flat marbles. Once dry, punch out ¹/₂" (1.3 cm) circles with your punch. Put a dab of clear dimensional adhesive on the flat bottom of the marble and stick it down on the punched-out circle of paper. Once dry, adhere to edge of box lid with heavy-duty adhesive.

2 **FLOWER KEYS** Brush the key with decoupage medium, lay tissue over it and pat firmly with fingers. Tear away the excess (dry) tissue and apply another coat of decoupage medium. Once dry, rub lime-green chalk ink over the paper to tint it. Rub maroon chalk ink on the edges of small paper flowers. Push an eyelet through the center of the flower and the key's ring hole and set it. Adhere the element to the box with heavy-duty adhesive.

3 **BOTTLE CAP CAMEO** Turn your 1" (2.5 cm) circle punch upside down and slide a sheet of the collage paper into it. Looking through the bottom of the punch, center the image of the rooster's head in the punch and press down to cut it out. Tint the white area surrounding the rooster's head with watercolor paint. Glue a bit of text onto the rooster image. Glue the little circle collage to the inside of the bottle cap and then fill it to the top with clear dimensional adhesive. Allow to dry. Once hardened, affix it to the lid with heavy-duty adhesive.

{ CELEBRATED CHEFS }

TOP 5 PEOPLE WHO HAVE INFLUENCED CHERYL
IN NO PARTICULAR ORDER

CAROL BURNETT As a kid growing up in the 1970s, I loved her show. She made me want to be funny. And dye my hair red. In grade school, whenever someone asked me what I wanted to be when I grew up I would say, "A cartoonist and a comedienne." With a flair for alliteration even as a buck-toothed youngster, maybe I didn't land too far off?

ERMA BOMBECK Again with the comedy, but this time written instead. Erma was real, ironic, sarcastic, and accessible. She saw the humor in motherhood. I have laughed myself to tears reading her essays on life and love. I have often wondered if I'm being haunted by her ghost.

JANE AUSTEN No sight gags or anecdotes about PTA meetings like the above funny girls, but her sharp wit, observations on the human condi-tion, and story-telling talents are without parallel after more than 100 years. I heart Mr. Darcy.

NANCY DREW When I discovered Carolyn Keene, I added spunky girl detective to my list of future occupations. Nancy is independent, smart, curious, and super stylish—and she has a really cool car. Trixie Belden is a poser.

SARAH CONNOR, THE TERMINATOR I love apocalyptic science fiction. Sarah is just a regular girl thrown into extraordinary circumstances involving homicidal cyborgs, time-traveling, star-crossed love, and lots of explosions. Implosions too. Props must also be given to Linda Hamilton's chin-ups and resulting arms in T2—killer.

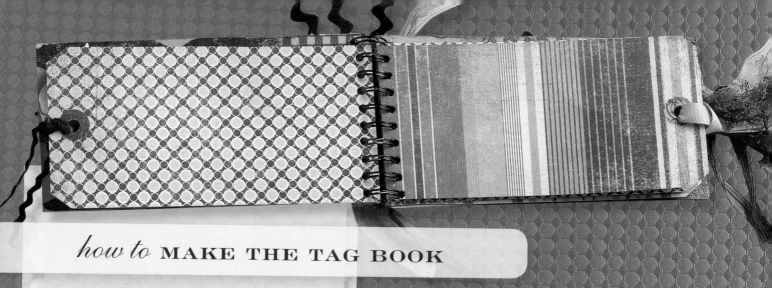

how to MAKE THE TAG BOOK

INGREDIENTS

Tag book (DiBona Designs)

Brass switch plate

Red and turquoise ribbons

Eyelets

Fruitcake Collection patterned paper by BasicGrey

Anna Griffin Roosters & Hens decoupage paper packs

4 $^3/_4$" (12 cm) Cabernet Toile & Woodland decoupage tissue pack

Red and green patterned scrapbook papers

Embossing ink

Gold embossing powder

Chalk ink rubber stamp pad (maroon & lime green)

Red dye ink pad

Blue-green acrylic paint

E6000 heavy-duty adhesive

Mod Podge decoupage medium

Diamond Glaze dimensional medium by JudiKins

Chicken-wire rubber stamp

Heat gun

$^1/_2$" (1.3 cm) and $^1/_4$" (6 mm) circle punches

Screw punch

1. Disassemble the tag book and decoupage the insides of the front and back covers of the tag book.

2. To embellish the back cover, trim red scrapbook paper to size and use the chicken wire stamp, embossing ink and powder, and a heat gun to emboss it. Attach to the back cover with a glue stick.

3. Repeat step for front cover using green paper. Add a strip of patterned paper (ink edges) and a flower key to the front cover.

4. Emboss the brass switch plate with the chicken wire pattern.

5. Trace the punched circles from the switch plate onto the text-printed paper. Cut out the small images of rooster and hen heads, glue them onto the text-printed paper where the circles were traced, and erase the pencil marks. Coat the images with clear dimensional adhesive and stick them to the backside of the switch plate so the images will show through the punched holes.

6. Glue the switch plate to the cover with heavy-duty adhesive. Then, use the heavy duty adhesive to glue an eyelet into the left screw hole of the switch plate as well as a key with an eyelet over the right screw hole.

7. Using one of the tags that came with the book, trace several tags onto double-sided patterned paper. Cut them out and ink the edges with maroon chalk ink. Punch a $^1/_4$" (6 mm) hole into the top of each tag. To make the hole reinforcers, punch out a $^1/_2$" (1.3 cm) circle from patterned paper (two for each tag) and then punch a $^1/_4$" (6 mm) circle into the middle of it. Line it up around the $^1/_4$" (6 mm) hole in the tag and adhere it with glue.

8. Slide a tag into the library pocket. Using an original tag as a template, punch out holes for the wire binding in the remaining tags and both covers. Reassemble the tag book and embellish with ribbon.

how to MAKE THE MINI BOX

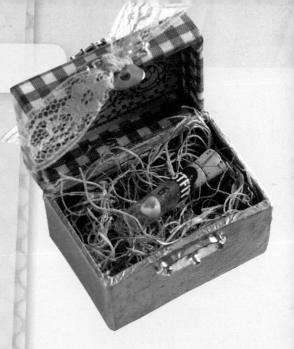

INGREDIENTS

Small paper box with hinge closure, approximately 2″ x 1 ½″ x 1 ½″ (5 x 4 x 4 cm)

Paper cigar band

Old leather pocket diary

Library card pocket

Kraft paper envelope approximately 3 ½″ x 5″ (9 x 13 cm)

Bottle caps

Bazzill Bitty Blossoms

Flat marble

Anna Griffin Roosters & Hens decoupage paper packs by Royal Coat

4 ¾″ (12 cm) Cabernet Toile & Woodland decoupage tissue pack by DMD Paper Reflections

Fruitcake Collection patterned paper by BasicGrey

Diamond Glaze dimensional medium by JudiKins

E6000 heavy-duty adhesive by Eclectic Enterprises

Embossing ink

Gold embossing powder

Chalk ink rubber stamp pads (maroon and lime green)

Red dye ink pad

Watercolor paints

Heat gun

1 TINY TOOTH BOX

Remove the clasp and decoupage the 2″ x 1 ½″ x 1 ½″ (5 x 4 x 4 cm) box with gingham and gold tissues. Once dry, reattach the clasp, add a bottle cap cameo with chicken feet (see "bottle cap cameo" instructions on page 91) and tie a piece of lace ribbon around the clasp.

2 OLD LEATHER DIARY

Stamp the cover with the chicken-wire stamp and embossing ink. Coat with gold embossing powder, shake off the excess, and set with a heat gun. Cover a paper flower with embossing ink and powder and set with a heat gun. Make another bottle cap cameo (see instructions on page 91) and glue onto the gold-embossed flower and then to the cover. Punch a small hole in the leather cover with a screw punch. From the inside, push a brad through a piece of ribbon, then through the hole in the cover, and secure the brad. Cover the flanges of the brad by gluing a collaged flat marble over them.

3 LIBRARY POCKET

Wash the front of the 3 ½″ x 5″ (9 x 13 cm) kraft envelope with turquoise watercolor paint and dry with a heat gun. Once dry, stamp with the chicken-wire stamp inked in red dye ink. Let dry. Using a glue stick, adhere the library book pocket to the envelope. Glue a 3″ x 3″ (8 x 8 cm) square of gold tissue paper on the pocket in a diamond orientation. Roughly tear out a piece of 2″ x 2″ (5 x 5 cm) collage paper that has been washed with turquoise watercolor to fit the gold square and glue it on top. Cut out and glue a rooster bust to the collage paper. Embellish with the collaged flat marbles and cigar band. Add scraps of paper and patterned tags with the ribbon left over from tag book to the library pocket.

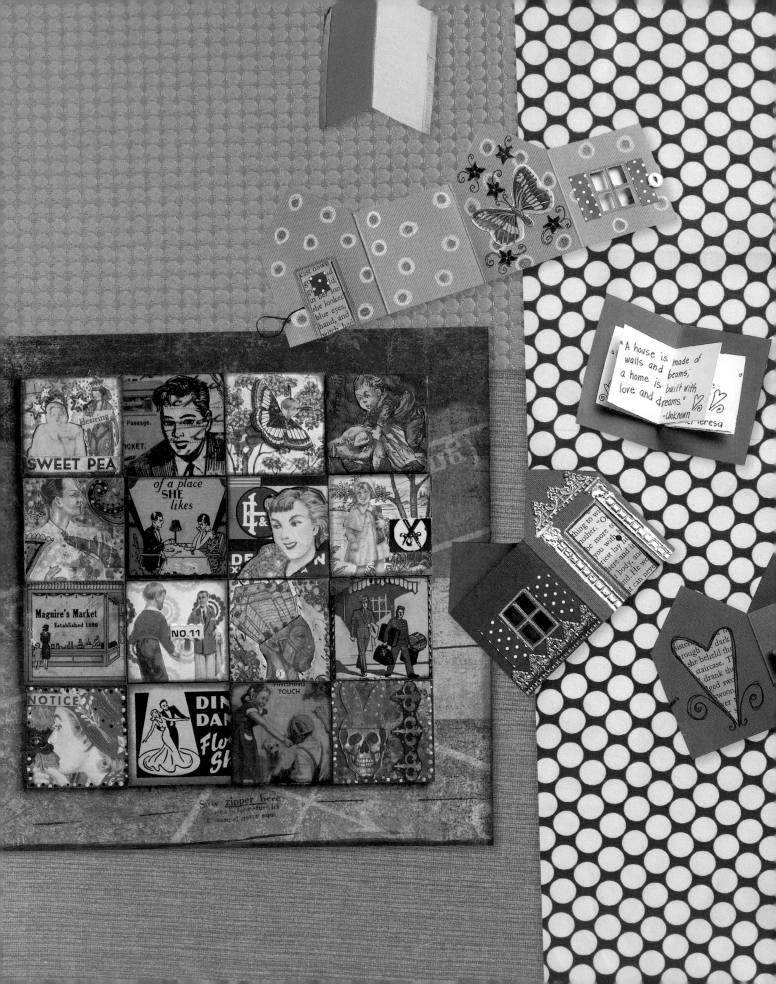

SWEET TREATS AND SPECIAL OCCASIONS

C: Debbi, do you know what the best thing about our long-distance friendship is?

D: The fact that I don't have to worry who's at the door when the bell rings?

C: No.

D: That I have Caller ID?

C: No.

D: That we're not obligated to go to each other's kids' soccer matches?

C: No! The best thing about being miles apart is the fact that I don't have to share my chocolate with you!

D: But you will share your fantastic ideas for making a sweet art treat, though. A sweet treat is a project that is high in wow factor, but low on cost, such as a small handcrafted book with meaningful text.

C: Kinda like "tastes great, less filling!"

D: Uh-huh.

C: A sweet treat could also be something super special, like a really cool project that you're going to give to someone very, very special. And, yes, I will share those!

D: Perfect, because this chapter is all about artsy crafts that do have a special air about them. They are items meant to be shared and shown off. Most projects have several components that can be created on their own as little gifts or party favors.

C: I do have to say that most everything in this chapter is just adorable, wouldn't you agree?

D: Actually, I would. A chapter full of adorable little projects. How sweet is that?

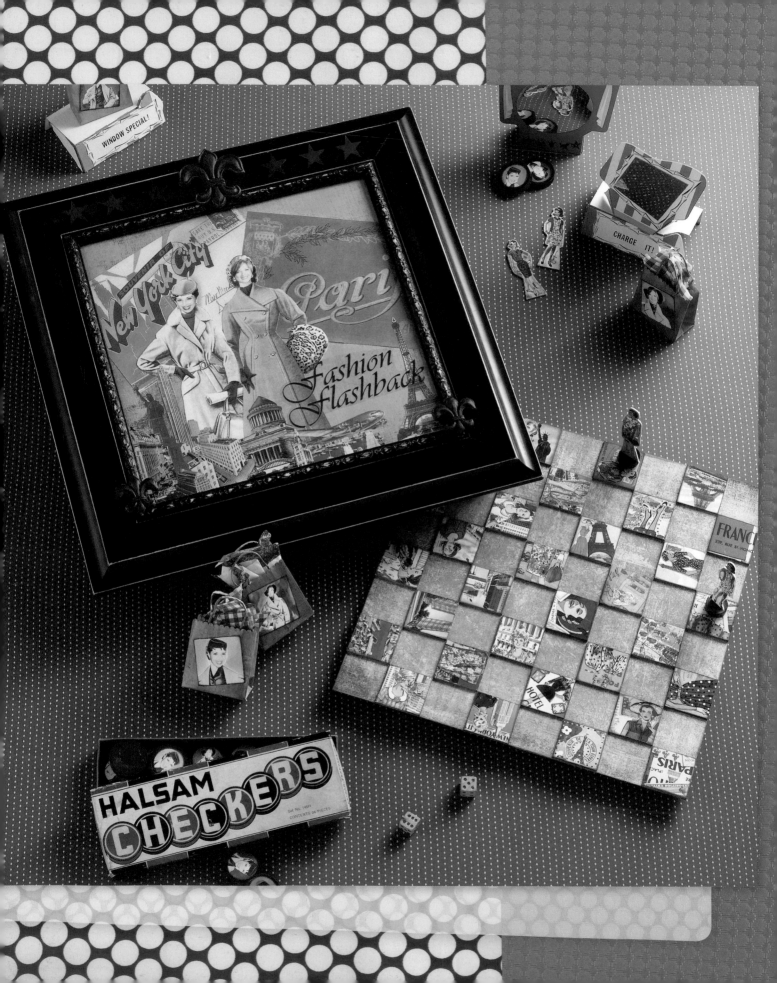

CHERYL'S ARTSY BOARD GAME
{ A SQUARE MEAL WITH ALL THE TRIMMINGS }

"FASHION IS NOT SOMETHING THAT EXISTS IN DRESSES ONLY. FASHION IS IN THE SKY, IN THE STREET, FASHION HAS TO DO WITH IDEAS, THE WAY WE LIVE, WHAT IS HAPPENING."
—COCO CHANEL

DO YOU REALLY WANT TO SURPRISE SOMEONE?

C: No, I mean, reeeeeeeally want to blow them away? Because, this is not the sort of endearment that can be bestowed upon just anybody for just any occasion. Take, for instance, the bond that Debbi and I share. It is so strong that, despite the fact that we have only met in person twice and against the odds that a twosome so opposite could find such common ground, I fashioned this game, with all of its exquisite detail, as a tribute to our friendship.

D: Um, Cher? Your game is wonderful, but aren't you being a little dramatic? We wrote a book together. It's not like we're the sole survivors of a plane crash.

C: I'm just trying to paint the picture, set the table, and add a little drama.

D: How unlike you.

C: Knock it off, you're killing my timing. Where was I? Oh, right! Parker Brothers and Hasbro don't have a monopoly on game-making. You can create a one-of-a kind art game to honor somebody special, commemorate a trip, or roast a deserving graduate or retiree. The game you see here is a fantasy adventure in which Debbi and I travel back in time. We tour New York City and Paris, and the game includes the fashions of the 1940s, 1950s, and 1960s.

Consider making a chess board with family members as the pieces, or a Candyland-inspired game. It would be fun to alter and customize an old Operation game for a friend recovering from surgery. Use your imagination, roll the dice and move your mice, pass go, and sink that battleship.

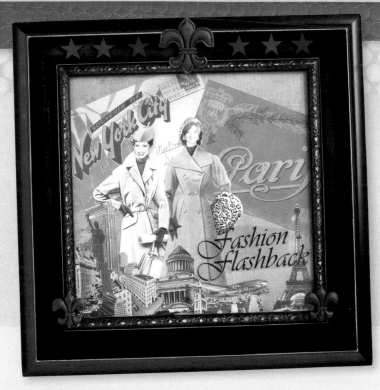

INGREDIENTS

Shadow box with interior dimensions of 12" x 12" (31 x 31 cm)*

12" x 12" (31 x 31 cm) foamcore

Two 18" (46 cm) pieces of wooden dollhouse trim**

Small miter box and saw**

Wooden embellishments**

Acrylic paint

Black antiquing medium

E6000 heavy-duty adhesive by Eclectic Products

* The size of your board will be dictated by the size of the shadow box you find; I found mine at the craft store.

* You can find dollhouse trim, a small miter box and saw, and wooden embellishments in the woodworking section of your craft store. A miter box is a tool that allows you to make cuts at a 45-degree angle. The little miter box and saw I found with the dollhouse supplies were the perfect size for mitering the tiny trim and well worth the $5 investment.

1 Since the size of everything you will make depends on the shadow box you use, purchase it first. You can find shadow boxes at a craft store, but many retailers offer them. Seen here is a black one with a distressed/sanded finish. The style was pretty, but plain. You can definitely fix that.

2 Paint the dollhouse trim to match the finish of the box and then lightly sand it. To make the shadow box look more finished, line the inside edge of the window with the dollhouse trim.

3 Measure the sides of the window and then cut the trim to fit. Miter the ends of the trim so that they will fit together perfectly. Miters are tricky so allow for some miss-cuts, waste, and under-your-breath cursing. Try to cut straight down so your corners aren't beveled, otherwise they will not lie flush (see image right).

4 Glue the trim to the glass with a heavy-duty adhesive. You can smear a little adhesive or white craft glue at the mitered corners where the trim pieces meet. If the glue shows through at the corners or if the cut is a little imperfect, just touch it up with paint once the glue dries.

5 Add any additional embellishments. Paint them to match if necessary. Distress with antiquing medium if desired. Adhere the decorations to the box with heavy-duty adhesive.

how to MAKE THE BOARD

INGREDIENTS

12" x 12" (31 x 31 cm) piece of mat board (any color, we're going to cover it)

Thirty-two 1 ½" (4 cm) square Bazzill Chips

1 sheet of 12" x 12" (31 x 31 cm) paper to cover the mat board

Copyright-free collage images from old sewing patterns, magazines, and vintage postcards

Patterned papers and scraps

Chalk inks in various colors

1 Collage the chipboard squares (see pages 30–33 for instructions). These squares will make up half of the board spaces—the balance will be left blank to allow the background paper to show through. I made 16 squares for NYC and 16 squares for gay París. Each square includes a background that was cut from a postcard and an image of a model on top.

> IF YOU DON'T WANT TO USE ANY ORIGINAL MATERIALS, SUCH AS PATTERN ENVELOPES AND POST-CARDS, SCAN AND PRINT THEM ON PHOTO PAPER AND USE THE REPRODUCTIONS. SCANNING THEM ALSO WILL ALLOW YOU TO RESIZE THE IMAGES FOR USE ON FUTURE PROJECTS.

2 If you have a lot of skill and patience or have a mat cutter in your possession, you can cut your 12" x 12" (31 x 31 cm) piece of mat board yourself. If you possess none of these things, like me, you probably have a very nice lady at your local frame shop who will cut your mat board to size for you (thank you, nice lady!).

3 Coat the mat board with gel medium. Align and lay a piece of 12" x 12" (31 x 31 cm) scrapbook paper over it, right side up. Gently smooth it out from the center to the edges with your hands or a clean brayer. Initially you may have some air bubbles, but these typically disappear once the gel medium is dry. The best way to line up the paper with the mat board is to hold the paper by two opposing corners with the center of the sheet hanging down slightly. Line it up visually and place it on the coated mat board and make contact with the middle first. Then approach the other corners and smooth down.

4 Once the paper-covered mat board is dry, start arranging the collaged squares. I put all of the NYC squares on one side of my board and all of the Paris squares on the other. You can orient the squares in the same direction or you can mix it up—remember, a game board is viewed from all four sides. Arrange the squares so that you end up with a checkerboard pattern—each square should alternate with an equal-sized square of patterned paper.

5 Once you have the squares arranged as desired, you can commit to gluing them. I used a glue stick for this job. Take the time to properly space the squares; you don't want any squares hanging off the edges of the board. That would just look sloppy, and we're all about being pretty.

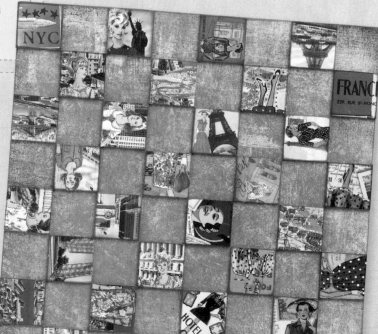

INGREDIENTS

1 sheet of 12" x 12" (31 x 31 cm) paper for the collage background

Transparency film, appropriate for your printer*

Headshot images of people who will be featured in the game

Model images from sewing patterns or fashion illustrations

Gel medium

Chalk inks and dye inks in various colors

Rubber stamps

* Transparencies are available for both laserjet and inkjet printers. Be sure to purchase the correct type of transparency for your printer; otherwise, you could ruin your printer.

1 To begin the collage, create the foundation. Measure the window of your shadow box from the back. Trim a piece of decorative paper about ³/₄" (2 cm) smaller in length and width than the glass. If a lot of this background paper is going to show in the collage, you may want to use something with a lot of texture but not a lot of pattern, which will keep your collage interesting yet prevent it from being too busy. As you move forward from this point, keep in mind that you'll want to make sure that whatever your focal point (i.e., the paper dolls), it will fit on this background. At this point, I also scanned postcards to incorporate into the background.

2 To create the cover girls for your collage, choose a photo of your face and a friend's to scan. Then, snatch some bodies to match them—I found fashion model illustrations for Debbi and me on the Internet. I liked the idea of making us really large with the city at our feet—kinda like Debbi-

zilla and Cher-Kong. Playing with the scale in this way adds interest to a collage, so I enlarged them to 8" (21 cm), printed them, and sized our faces to match. Print the bodies on matte photo paper and the new faces on regular printer paper so the faces are thin and easy to work with.

3 Silhouette cut the faces. Don't cut around the bodies yet because you'll be scanning everything one more time. Create your dolls by attaching the heads to the bodies. You may have to use your craft knife to cut a slit in a hat or a neckline to tuck the head in, which is why the thicker matte photo paper works better for the body, and the thinner works better for the face. You can camouflage the evidence of the cut-and-paste surgery by coloring the raw edge with a colored pencil. Now, scan the bodies with their new faces and print so you have seamless paper dolls. Carefully silhouette cut them with small scissors and a craft knife.

4 The collage is made up of several different components that were silhouette cut from vintage postcards and copyright-free photos I found on the Internet. Once I had all the pieces I liked cut out, I assembled them much like a puzzle, using a glue stick to adhere them at the bottom edge.

5 If you are really good at hand lettering, you may want to write your title on the collage. I don't trust myself, and that collage was a lot of work, so I found a font I liked and printed my title onto a sheet of transparency film so it would appear to be printed over the top of the collage. I cut it out and arranged the title to create a visual bridge between the dolls and the Eiffel Tower because the tower had little to anchor it to the main collage. I used a glue stick at the edge of the paper to stick the transparency to the collage at one end, since it was going to get sandwiched between the glass and the foamcore backing.

6 Now it's time to insert your collage into the shadow-box window. Think of it as a "collage sandwich"; the glass from the window and a piece of foamcore are the bread, the collage is the meat. The shadow box I bought had small wooden wedges that were screwed to the frame holding the glass in place from the back. I removed them with a screwdriver and placed the collage face down in the window. The same nice lady who cut my mat board cut my foamcore insert to 12" x 12" (31 x 31 cm) (thank you, again, nice lady!).

7 Because we cut the base paper for our collage about ³⁄₄" (2 cm) smaller than the glass, there will be a small margin around the collage. Put the collage face down on the glass, check it from the front to ensure it is properly aligned, and tape it in place with some clear tape. Then put a small amount of heavy-duty adhesive on the glass margin around the collage, and wedge the foamcore into the recess. Do I need to say it? Allow to dry.

{ A WELL-BALANCED COLLAGE }
ENJOY CHERYL'S TIPS FOR A CREATIVE AND BALANCED COLLAGE

Do you notice anything particularly stunning about this collage? Oh, besides Debbi and me. I am sure you are saying, "Wow! The fluidity of the design is such that this collage looks almost animated! The elements—why, they are so impeccably placed with purpose and, and . . . gusto! The scene Cheryl created has so much depth and dimension."

Aw, shucks. Thanks. It was nothing, really. I just chose elements that related to each other visually, and assembled the elements in such a way that they maintained that relative integrity via a seamless integration into the background. To make this mumbo jumbo make sense, here's what I really did:

✧ Note how the Pan Am Jetliner covers the raw edge of the bit of skyline I chose. The wing is behind the top of the white skyscraper but in front of the museum that's next to it, while the tail is totally obscured.

✧ Notice how the buildings overlap each other, creating the illusion of distance and size by hiding a straight-cut edge.

✧ The figures of Debbi and me were cut out separately but posed together. My elbow is in front of Debbi's arm, but her coat is in front of my bag—this integrates the images and makes them look less pasted on.

✧ The collaged skyline grounds our figures while certain parts of architecture jut up and overlap our figures, the background, and the postcards.

Everything is anchored and all of the elements relate to one another; I successfully assimilated them into a composition that flows visually.

✧ I played with the scale and placement to add interest: the Statue of Liberty looks nearly as tall as a skyscraper; the suspension bridge in front of the museum building is small by comparison. Not all the images are at the same angle, but it works. The gap between NYC and Paris is intentional, to symbolize the Atlantic.

✧ I fought the urge to center the main images, and in doing so, I noticed that slightly off-center is much more interesting. Debbi and I are not located center stage, yet there is no doubt that we are definitely large and in charge.

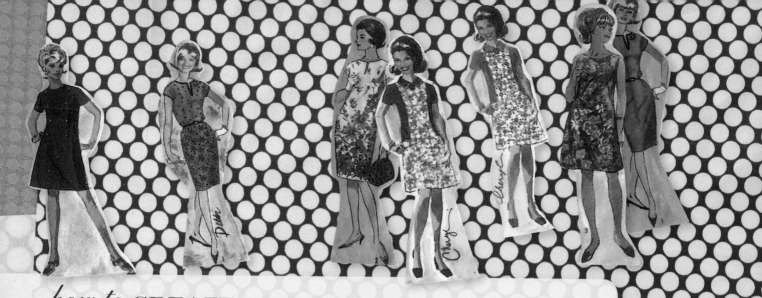

how to CREATE THE SHRINKY SHOPPERS

INGREDIENTS

Grafix printable plastic shrink film in white

Headshot images of people who will be featured in the game

Scans of the paper dolls previously created (optional)

A pair of wooden dice or small wooden checkers for the bases

Oven

Dremel rotary cutting tool with cutting blade and safety goggles

Dye inks

Waterproof markers

Rubber stamps

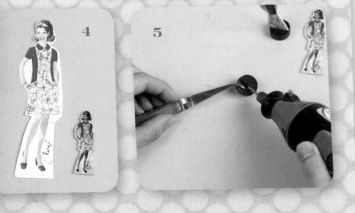

1 Just like you created paper dolls in the likeness of you and a friend for the cover collage, you're going to create tiny likenesses for the game pieces. You can use the same paper dolls from the cover art (remember, you have the scans), you can use the same face images but with different bodies, or you can totally start from scratch.

2 Whatever you decide, print your likenesses on shrink film according to the manufacturer's instructions. These films tends to shrink to about 50 percent of the original printed size so be sure to print your image 50 percent larger than the desired finished size. You may need to enlarge or reduce the image before printing. If you are working with the paper dolls you created for the cover art, you may need to slightly reduce those giants to equal your desired size.

3 Because the shrink film accepts ink, you can color and embellish it before you shrink it using dye inks, Sharpies, and rubber stamps. Color in the clothing, put polka dots on the skirt, write something on it. Color in the background.

4 When cutting out the figure, don't completely silhouette cut it. Instead, leave a margin around the body while making a tighter cut around the head. Now, it's time for the magic! Shrink the plastic according to the manufacturer's instructions. I use my toaster oven for shrinking; it's small, uses little energy, and I can easily ooh and aah over the process from the counter top. The shrinking can cause curling, so you may have to gently press the shrunken objects flat with a flat object (I like to use a tile trivet) after they come out of the oven (see image left).

5 To create a base for your shrinky shopper, take a small wooden piece, like a checker or a dice, and use a rotary tool to cut a channel in which you can wedge the shopper (see image left). Be careful with the power tools! Hold the checker with pliers, wear safety glasses, and take your time (I know I'm not a patient person, but this time, I insist!). If you don't have a rotary tool or are afraid to use it, you could brace the piece in your small miter box and saw a channel into it. It's more work, but hey, you'll burn a few calories, and may save a finger!

INGREDIENTS

16 wooden checkers

Small paper gift bags (Martha Stewart)

Tissue paper

Headshot images of people who will be featured in the game

Circle hole punch slightly smaller than diameter of checkers

Watercolor paints

Chalk ink

Matte photo paper

1 To personalize the checkers, create a new head-and-shoulders photo collage in the likeness of yourself and a friend and scan. Use your image-editing software to convert the images to black-and-white and reduce or enlarge to desired size.

2 Print the images multiple times on matte photo paper. Once dry, cover with a thin towel and press with a dry iron to seal in the ink. Create a colorful background wash around the image with watercolors. Allow to air dry or hit with the heat gun.

3 Take a circle punch, turn it upside down, insert the image so you can see it through the opening at the bottom, and punch it out (see image left). Drag some chalk ink across the edges (I matched the checkers) and then use a glue stick or Xyron machine (this handy machine will apply adhesive to the backs of your own paper images, essentially creating a sticker) to adhere the image to the checkers.

4 Paint the white bags with watercolor paint. When they are dry, stuff them with tissue.

5 Follow steps 1, 2, and 3 from the checkers, but instead of using a circle punch in step 3, use a large square punch this time. Drag some black chalk ink across the edges and adhere them to the bags with a glue stick or Xyron machine.

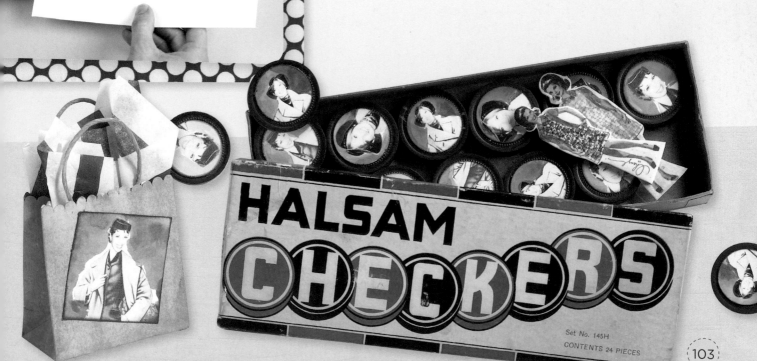

HALSAM CHECKERS

Set No. 145H
CONTENTS 24 PIECES

C: Debbi, if you were asked to describe me, what would you say?

D: I would say, "Cheryl Prater is smart, funny, competitive, and confident. She loves attention and seemingly has no fear of what anyone will think of her."

C: Of course you can distill me in one sentence.

D: Well, what would you say if you were asked to describe me?

C: I would say, "Debbi Crane is a wife first, a mother second, and a life-long maker of art, conveying a message regardless of the vehicle. Debbi has something to say, and she knows exactly how she wants to say it. She is methodical, consistent, and unflagging, beginning all things with the end in mind. Whether she applies them to her five-years-and-counting daily art commitment or training for another half marathon, Debbi possesses enviable stick-to-itiveness and tenacity—she does not falter. She is on a mission from God to bring daily art to the world."

D: You know, Cheryl, I have to admit that when you first sent that e-mail, I thought, "How could we be friends?" We did not know each other, and I generally keep to myself. You are one of those people who thinks everybody will like you. I am one of those people who thinks nobody will like me. I would NEVER send such an e-mail to a total stranger.

C: But aren't you glad I did?

D: Absolutely. But when we first set out to write this book, I got a little caught up in how really different we are. We live far apart and have nothing in common other than art, and we approach that in COMPLETELY different ways. You are an executive recruiter; I'm an elementary-school art teacher. You have boys, I have girls. You have lived in lots of places; I have only lived in Bedford, Indiana. You have your Greek/Italian ethnicity; I married a guy with my same last name (FOR THE LAST TIME, Cheryl, we are not kin). What would we even have to talk about? How could we write a book together?

C: Hey, let's not forget the things we DO have in common: we're both working mothers with two kids, we're both married to quiet, tolerant men who have put up with us for the better part of two decades. We were both born in 1967, we're both *Cloth Paper Scissors* cover girls, we're both the eldest of three, neither of us studied art in college, we're both worrywarts, and we definitely share a snarky, sassy sense of humor. Besides, I think it's the differences that make us strong. I love how it's so easy for me to yank your chain because of your self-inflicted rules,

rigor, and regimen. Or how you take me to task for my constant fluidity and comparative chaos—because in my world, nothing is ever set in stone, there is no routine, and every day brings a surprise.

D: As an artist, I am trying to learn this from you: Sometimes it's okay to sit down in front of a pile of stuff and start putting things together with no idea of the outcome. As a person, you have taught me that corporate types can be cool and nice and sincere. Almost like us regular people.

C: I am always learning from you about art, about myself, about the creative process. Your relentless push toward achieving inspires me to try things and do things I wouldn't have attempted before we met.

D: That push is definitely the difference between me and regular people. When regular people have an outlandish impulse, they dismiss it. Not me. It is an automatic double-dog dare to myself. Throughout this journey, I fully planned on using the excuse "I can't do that/be there/help you because I'm writing a book." I never did a single time. I was there for my girls, both very active athletes, 100 percent. I even managed to make stuff for the school Christmas program.

C: I still can't believe that we signed the contract to write this book in July 2007 and turned in all the artwork and manuscript five months later. It was an insane timeline for two busy working mothers that I NEVER would have committed to without your constant nagging. Debbi, you can leap tall buildings in a single bound and when someone marvels at you for accomplishing some amazing, superhuman feat, you look at them plainly and say, "What? I don't feel like I did anything."

D: You're a pretty good juggler yourself: twin boys, a busy husband, and a high-powered job. You had plenty of life going on while we wrote this thing. I know you weren't feeling 100 percent terrific for a long while, but like the trooper you are, you pulled through with flying colors. And a little brown, for that Cheryl touch. I didn't have to nag you that much. I only had to send you one e-mail that said "Don't make me come down there."

C: So, Debbi, where do you think this journey will take us to next?

D: I suppose I don't care, as long as I get to retain the title "Chief Eye Roller and Straight Man."

C: Who do you think will play us in the movie?

D: Dean Martin and Jerry Lewis.

C: Which one plays me?

D: Oh, for cryin' out loud, Cheryl. Who do you think?

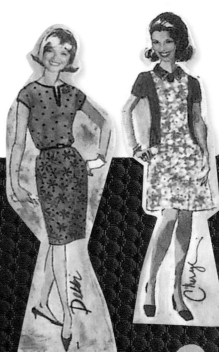

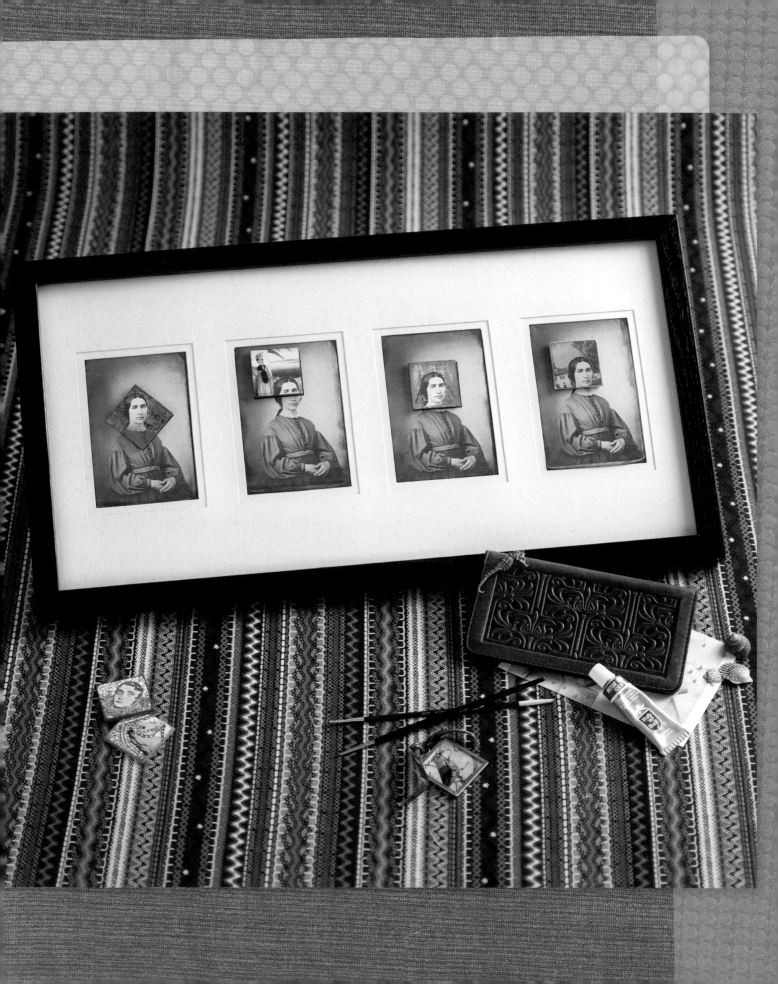

CHERYL's MINI-COLLAGE FEAST
{ GLUTTONY DOESN'T HAVE TO BE A DEADLY SIN }

"THE BEST WAY TO HAVE A GOOD IDEA IS TO HAVE LOTS OF IDEAS."
—LINUS PAULING

LITTLE DID I KNOW THAT THESE LITTLE DITTIES COULD BECOME MY VISUAL JOURNAL FOR THE ENTIRE YEAR.

When I started making mini collages, I just loved using all of my little gems of scraps to create wonderful items that were like small reflections of my large life. But they began to pile up. It turns out these collage squares are great building blocks for trinkets, larger collages, and assemblages.

One of my favorites is the mosaic of minis. If you like the squares individually, you will love the way they interact when placed in a mosaic. The composition can read like a storyboard or be comprised of collages that only relate in color. The beauty is that you can arrange them the way you like them.

I also incorporated the collages with a few of my totally favorite products of the moment (the moment of press time, that is). Ranger Inkessentials Memory Frames make instant jewelry from collaged 1 1/2" (4 cm) squares. Perfect for the solder-impaired, impatient crafter, or those who can't be trusted with electric tools. Also sold by Ranger are 1 1/2" (4 cm) squares of Memory glass to go with the frames. The charms I created with them make great necklaces or tree ornaments.

If you haven't oohed and ahhed over Martha Stewart's craft line at your local craft store yet, what the heck are you waiting for? A hand-engraved invitation? Even *The Martha* doesn't have time to send those out, okay? While you're there, pick up a 6 1/4" x 6 1/4" (16 x 16 cm) Specimen Collector Box to frame up one of your tiny artworks like I have on the next page. Such a little focal point in a comparatively big frame says: "Look at me! I may be small, but I'm important!"

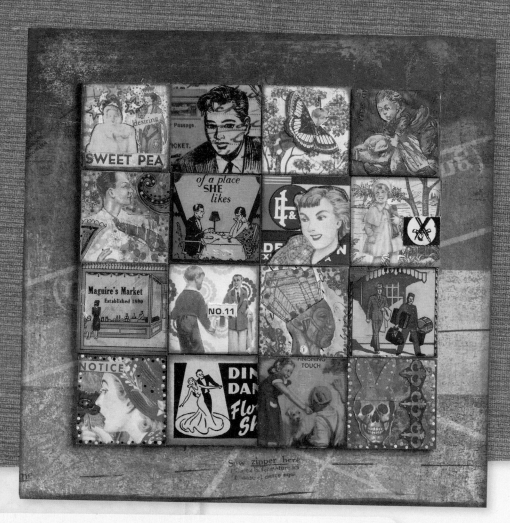

how to MAKE A MODULAR MOSAIC

INGREDIENTS

8″ x 8″ (21 x 21 cm) piece of medium density fiberboard*

8″ x 8″ (21 x 21 cm) sheet of scrapbook paper

Sixteen 1 ½″ (4 cm) collages

Gel medium

Black chalk ink

4″ (10 cm) brayer (optional)

* Mine was 1″ (2.5 cm) thick and left over from a Tilano Fresco project kit. You could easily substitute with balsa wood, mat board, or foamcore.

1. Skim gel medium on the 8″ x 8″ (21 x 21 cm) surface board and place the 8″ x 8″ (21 x 21 cm) scrapbook paper over it. Brayer or press down gently with your fingers to ensure even adhesion to the surface board. Let dry—sorry kids, the heat gun won't bail us out of this one.

2. While the above mentioned is drying, experiment with the arrangement of the squares in a 4-across/4-down pattern on your worktable until you are satisfied.

3. Lay your 16 squares on the background the way you want them and adhere them into place.

4. Ink the edges of your paper and board with black chalk ink so no white edges show. If you used thick medium density fiberboard for a base surface as I did, the inkpad ain't gonna cut it. Rub it instead with black acrylic paint.

how to MAKE A SPECIMEN SAMPLE

INGREDIENTS

Martha Stewart 6¼" x 6¼" (16 x 16 cm) Specimen Collector Box

Completed 1½" (4 cm) collage

6" x 6" (15 x 15 cm) piece of watercolor paper

1" (2.5 cm) wooden circle

1" (2.5 cm) wooden block*

Acrylic paint

Texturizing items

Gel medium

* These can be found by the bags full in the woodworking aisle of your craft store.

1. Following the instructions in Appetizers: Background Wonderland (see pages 34–37), create a textured background on the watercolor paper using gel medium and acrylic paint to fit in the box. Let dry.

2. Mount a 1" (2.5 cm) wooden circle on the back of the collage square you intend to frame—it will pick it up off the background and add dimension.

3. Mount the wooden-backed 1½" (4 cm) collage onto the background you created in step 1. Okay, you caught me, I broke down and centered mine in the example, but I didn't measure so it doesn't really count as perfect.

4. The box has a hang tab, so look at the back and orient your collage appropriately if you intend to hang the box.

5. Spread gel medium on the back of the background paper and on the fabric inside the specimen box and adhere. You may need to stack a book or two on it so it dries flat.

how to MAKE A CHARM

INGREDIENTS

1 mini collage

1½" (4 cm) Ranger Memory Frames

Ranger Memory Glass to fit (optional)

Sheet of mica (optional)

Ribbon or short bead chain to hang it from

1. This is so easy to make. You just slide your mini collage into the frame, stick the little tab through the slot, and bend it closed. If your collage seems too small for the frame, cut a piece of mica to 1½" (4 cm) and overlay it on your collage. This also gives your piece some extra sheen.

2. String it on a ribbon or short bead chain.

3. Be ready to answer all the compliments you'll get with "Really, you like it? I made it!"

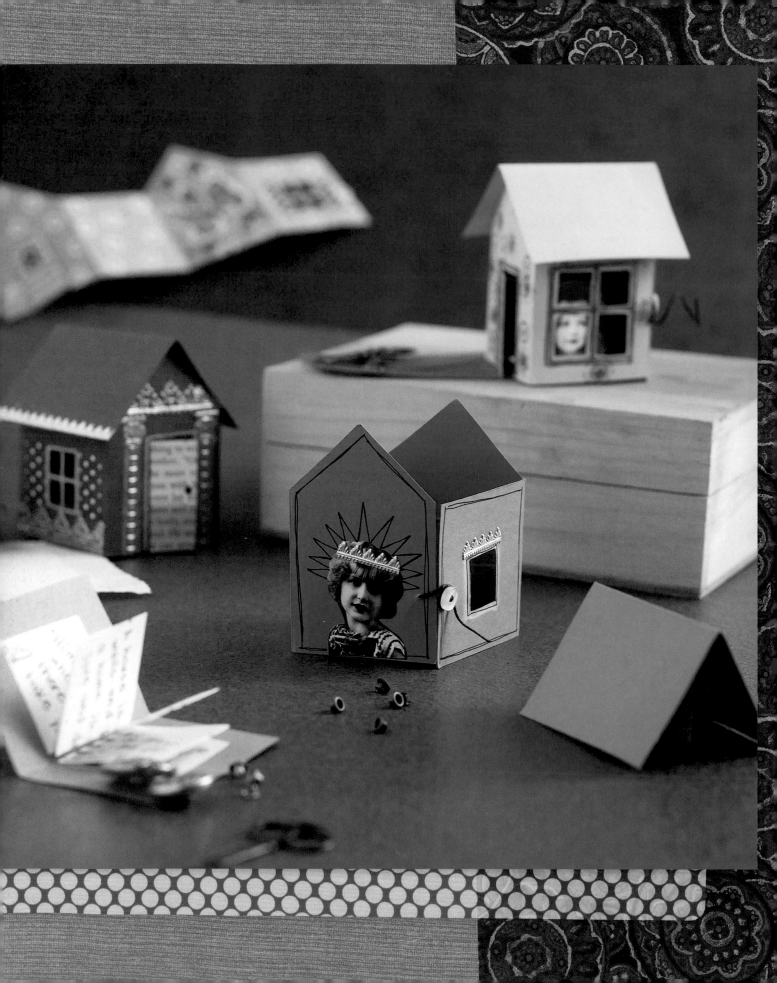

DEBBI's COTTAGE CARDS
{ SWEETER THAN CUPCAKES BUT WITH FEWER CALORIES }

> "GREAT THINGS ARE DONE BY A SERIES OF SMALL THINGS BROUGHT TOGETHER."
> —VINCENT VAN GOGH

SHARE THE LOVE. SHARE THE CUTE. SHARE THE ART.

These adorable little houses are three-dimensional greeting cards, suitable for any number of occasions, depending on the theme of the text inside the book roof. The cards would be a perfect way to celebrate a family reunion, a housewarming party, or the holidays. You can use all those scraps that are too little to use on large projects, but too good to throw away to make the tiny doors and shutters. Doodle bricks and window boxes or dress them up for the special occasions. They are fantastic treasures to send as holiday cards, but a fully built, prefab paper house just isn't cost-efficient to mail. If sending out to friends, they fold flat for easy and cheap mailing. Just make sure to mark the envelope "some assembly required."

This project is designed to be made in a "batch," or as they say in bookbinding, an edition, so the instructions will walk you through an assembly-line approach. Assembly-lining craft projects such as this will save you loads of time. You should keep a few points in mind when creating projects this way. First, be clean and organized. Also, be task-oriented about the project, and work on one task at a time. For example, when I made these cards, I worked on the roofs one night, the pages another, and the houses the next. Oh, and always make extras of everything because you will no doubt fudge a few (think of the extras as the sacrificial first pancake that always gets fed to the dog). Finally, make sure you have a big enough work surface to allow you to lay out all of your parts.

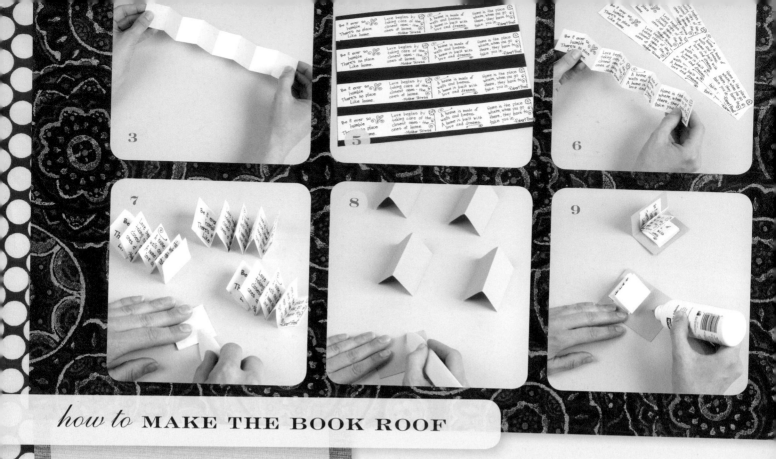

how to MAKE THE BOOK ROOF

INGREDIENTS

Assorted cardstock

Photocopied or word-processed text

Bone folder

Sheet of dark paper

1. Decide on a theme for your book and find an appropriate poem or four quotations that resonate with you. You could even use your own words in the book!

2. Whatever text you choose to put in the book, divide it into four roughly equal parts.

3. Cut a 1 1/2" x 11" (4 x 28 cm) strip of paper (white printer paper is fine). Fold it in half, short end to short end. Fold that in half and then in half again so that the strip is divided into eight equal panels when you open it up (see image above).

4. For these books, I hand wrote one quotation about "home" across each set of two pages, adding hearts and swirls. You could just as easily word process the text and use clip art. How you create the thing isn't as important as creating the thing. Do it the way that seems

right to you.

5. Make three white copies of the finished strip for a total of four. Adhere them to a dark sheet of paper and make a few extra copies, on whatever color paper you like, so that there will be one strip of text for each cottage card you plan to make (see image above).

6. The dark backing paper allows you to easily align your ruler with the edge of a strip and cut it out neatly with your craft knife. Cut all the strips out and fold each one as you did the original (see image above).

7. Open the strips, and, using the creases you made in step 6, refold each strip accordion-style, back and forth, like the paper fans you made in grade school. Fold so that when you are done with each, you see the blank back of the first panel facing up. Crease all the folds with the bone folder for extra crispness. These are the text blocks, or pages, for the book roofs (see image above).

8. Cut a 2 1/2" x 3 1/2" (7 x 9 cm) cardstock roof for each cottage card you are making. Fold each in half, short end to short end, and crease with the bone folder (see image above).

9. Use either white glue or a glue stick to adhere a text block into the center of each roof. Apply the glue to only the blank backs of the first and last pages which are the top and bottom of the closed accordion (see image above).

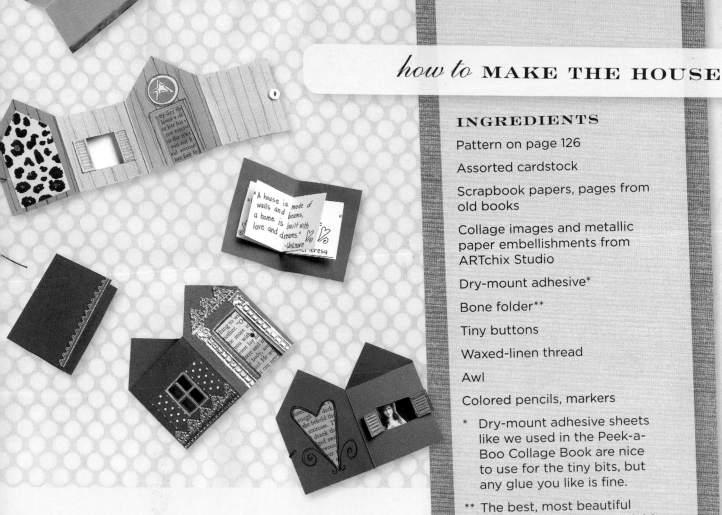

INGREDIENTS

Pattern on page 126

Assorted cardstock

Scrapbook papers, pages from old books

Collage images and metallic paper embellishments from ARTchix Studio

Dry-mount adhesive*

Bone folder**

Tiny buttons

Waxed-linen thread

Awl

Colored pencils, markers

* Dry-mount adhesive sheets like we used in the Peek-a-Boo Collage Book are nice to use for the tiny bits, but any glue you like is fine.

** The best, most beautiful handmade ones are available from www.shannaleino.com.

1 Use the template to cut out your cottages. Crease with a bone folder on the dotted lines.

2 Use any combination of cutouts and hand drawings to make doors and windows. Don't worry about scale. Any size square will read as a window; any size rectangle will work for a door. I like to cut out the doors and windows and then draw around the openings with fine black marker and colored pencil.

3 Use the metallic paper trim for the houses in the nice neighborhood.

4 Cut out some tiny faces and let them peek out of some windows. Again, scale isn't important.

5 To close the four walls so the house will stand up, use your awl to poke a hole in the center of one open end. Tie a knot in the end of about a 4" (10 cm) length of waxed linen thread and pull it inside and then out through the hole. In the center of the other open edge, sew a tiny button with waxed-linen thread. Wrap the thread around the button and add a contrasting roof to finish (see image right).

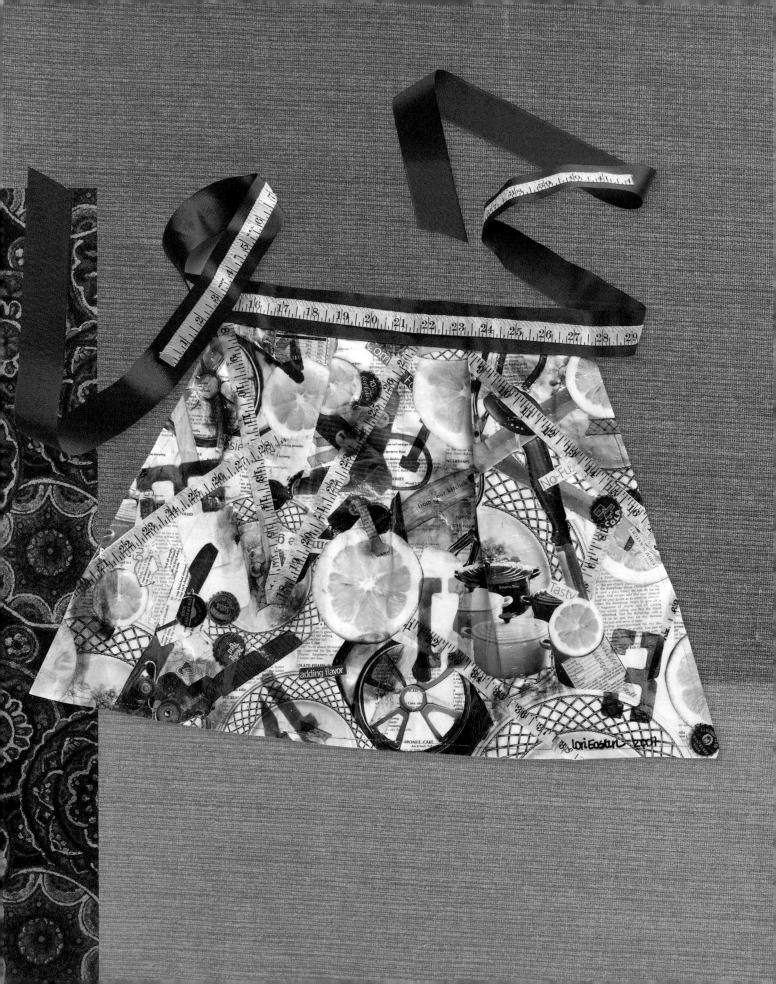

GUESS WHO'S COMING TO DINNER?
MIXED-MEDIA APRON GALLERY

C: Debbi, I'm stuffed. What could possibly be next?

D: Our potluck, duh!

C: Potluck? How can this chapter be a potluck? All of the "dishes" are aprons. Aren't potlucks created when everybody brings a different dish?

D: Okay, well, it's kind of like a potluck of artists, then. Or a themed potluck, like Mexican night, only we're having apron night!

C: Okay. Um, why?

D: It's symbolic. For most of history, women have not been allowed or encouraged to make art. When we look at the Renaissance, women weren't artists; they were subjects. It wasn't until the 1950s and 1960s that women, at least American women, even had time to make art. Housewives suddenly had all the modern conveniences—a washing machine, dryer, vacuum—which freed up their time to make art. When I talk about my daily art commitment with other women, the comment I hear most often is "How do you find the time?" Wow, I did not know there were so many women who still had to churn their own butter.

C: Okay, let me make sure I've got this straight: The apron potluck is a celebration of women's art as well as the fact that women are no longer tethered by society's apron strings, which prevented us from making art?

D: Exactly. It is also symbolic of the many roles women play. Plus, it goes really well with this whole cookbooky vibe we've got goin' and the idea that we are encouraging readers to have their own interpretations of our recipes.

C: Hey, you stole my adjective! I said cookbooky first.

D: Now, Cheryl, sharing is caring. Let's now share with the readers the wonderful array of materials, methods, and meanings that lie on the pages that follow.

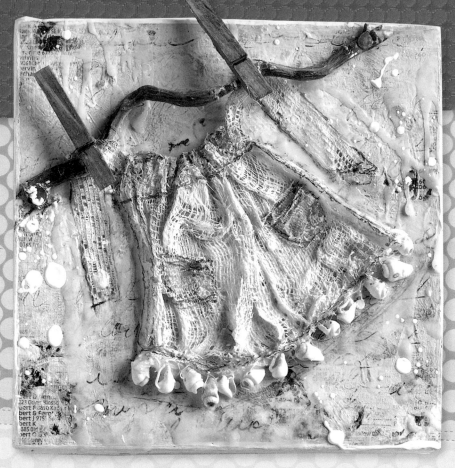

{ DIMENSIONAL COLLAGE APRON }
katie kendrick

INGREDIENTS

Acrylic paints and mediums

Beeswax

Oil pastel

Cheesecloth

Layered papers

Vintage lace

Found stick

Brass tacks

Thread

Tiny shells

My mother loved her aprons. She wore them whenever she cooked, canned, or washed dishes. Because I love to sew and she didn't, her Christmas request of me each year was a homemade apron. I hung this apron from a stick because it reminds me of clothes drying on the clothesline, another fond memory from my childhood.

6" w x 6" h (15 x 15 cm)

{ PATCHWORK APRON }
debbi crane

INGREDIENTS

Paper

Fabric

Watercolor paint

Acrylic paint

I created this apron as a self-imposed final exam for the book-writing process. I used scraps from projects in this book and photocopied pages from my sketchbook for the patchwork apron.

10" w x 13" h (26 x 33 cm)

{ CERAMIC CAST AND COLLAGED APRON }

carol j. watson

INGREDIENTS

Lino print

Collage materials

Glazed red clay

Metal elements

As an icon, the apron both hides and highlights elements of woman-hood. This mixed-media piece speaks specifically to mothering, social expectations placed on women by themselves and others, and the complex nature of the woman behind the apron.

18" w x 26" h (46 x 66 cm)

{ CLAY APRON }
laurie mika

INGREDIENTS

Polymer clay

Fiber

Mica powders

Rubber stamps

Eyelets

Beads

Jewelry parts

Tiny utensils and tools

This miniature apron turned out to be completely different from what I imagined when I first started it. As I began creating the apron, the idea of creating a painter's smock struck me, and I liked combining the two different facets of my life as both a mother and an artist. So it was fun creating the three-dimensional pockets in which to place the tiny utensils and the pencil and paintbrush, which symbolize the two roles I play in my life.

3" w x 7" h (8 x 18 cm)

{ SCANNING APRON }
lori fein easterlin

INGREDIENTS

Interfacing

Pages from a vintage *Joy of Cooking* cookbook

Scanned and inkjet-printed color images of kitchen utensils from my kitchen drawers, fruits and vegetables from my refrigerator, vintage soda bottle caps, and buttons

Golden gel medium

Golden fluid acrylic paints

Golden clear tar gel

Grosgrain ribbon

Vintage tape measure

Sewing machine

Needle and thread

This fall, I found myself back in the kitchen, responsible for feeding my family, after a two-year hiatus during which my husband reigned supreme as chief cook. This was not good news to me as I do not enjoy menu planning or grocery shopping. I also do not enjoy cooking, and I loathe cleaning up the kitchen! I fashioned this apron in my studio to keep me laughing in the kitchen as I chop, stir, fry, boil, steam, serve, clear, and clean (ugh!) each evening.

24" w x 24" h (61 x 61 cm)

{ COLLAGE APRON }
sisters deb silva and judy perez

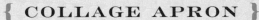

INGREDIENTS

Fabric

Rickrack

Embroidery floss

Red woven hearts

Vintage floral illustrations

Sewing pattern

Decorative paper

Textile paints

White ink

White Signo Uniball pen

Golden glaze

Gold scrap

Rubber stamps

The inspiration for our apron was actually working long distance. We needed to come up with a plan that would play to each of our particular strengths. With Judy's talents for sewing, thread work, and painting, it made sense for her to construct the apron and mail it to Deb, who then used her talents in altered arts to make it a finished piece.

15" w x 17" h (38 x 43 cm)

{ ROCKIN' APRON }
kim sherrod

INGREDIENTS

Record album and cover

Rickrack

Tulle

Thread

Beads

Glass

Glitter

This apron was inspired by my brother's record collection, which numbers in the thousands, and my love of paper dolls. I combined the two elements to suggest that the Iconic Apron can also be a sculpture that rocks your heart with delight. I had fun melting the record and testing different ways to manipulate the "hot wax."

12" w x 12" h (31 x 31 cm)

{ APRON ARMOR }
betsy karounos

INGREDIENTS

Aluminum

Screening

Wire

Chain

Hardware

The title of the piece is *Apron Armor*. It is designed for those times in life when extra protection is needed. The designs on the aluminum resulted from two discoloration techniques. After applying an oil-based ink-resist pattern, the bib was immersed in boiling water with eggs until it darkened. The skirt was stained by boiling the aluminum in a bath of baking soda with badly tarnished silver, which transferred the tarnish to the aluminum.

18" w x 30" h (46 x 76 cm)

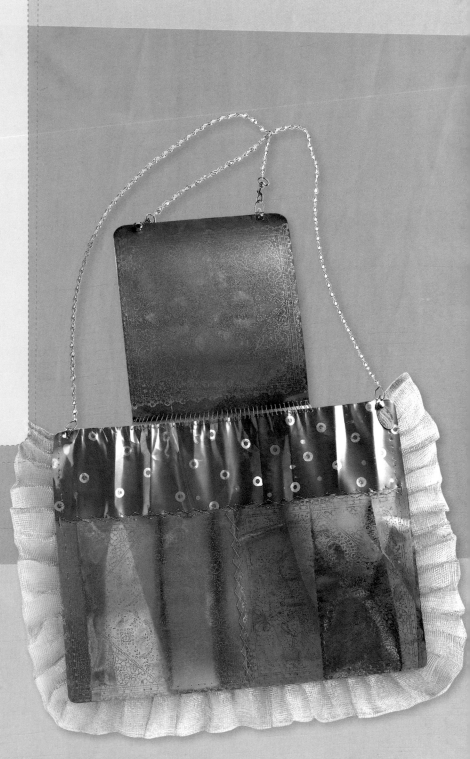

Cheryl Prater (left) and Debbi Crane (right)

CHERYL PRATER

Cheryl Prater lives in an Atlanta suburb with her husband, Mark, their thirteen-year-old twin boys, Reese and Connor, and their Champion Dachshund, Trumpet. After many years of acid-free scrapbooking, Cheryl began experimenting with collage and mixed media when her scrapbooks got too fat to close. The format became too restrictive. Her media-mixing reached critical mass after her discovery of *Cloth Paper Scissors* magazine and the realization she was not alone in her obsession—there was an entire nation of similarly afflicted artsy types! Until someone offers her a TV show making her the Rachael Ray of crafting, Cheryl will continue to work full-time as an executive recruiter while making stuff, writing books, and teaching workshops as time allows. Visit her website at cherylprater.com and her blog at praterposte.blogspot.com.

cheryl would like to thank . . .

Tricia Waddell, Patricia (Pokey) Bolton, and all the folks at Interweave. Also, Jane Powell at Random Arts, who encouraged me to submit Sixtyopoly to *Cloth Paper Scissors*, launching me on this fabulous journey. Thanks also to my coauthor, Debbi Crane, for her patience and tolerance, sharp wit, hilarious one-word e-mails, and unwavering vision.

DEBBI CRANE

Simply put, I am a wife, mom, teacher, and art maker. I have been married to my husband, J.R., since 1989, and we have two teenage daughters, Whitley and Courtney. I am an elementary school art teacher to about 400 students in grades one through five. I never tire of those sweet faces glowing with pride in their creations. The best compliment I ever receive at school is when a tiny first grader looks up at me and tells me I'm the best art teacher he or she has ever had! I have made art my whole life. When I was a child, often grown-ups told me I would be an artist when I grew up. I guess they didn't know I already was. Most of my waking hours are spent with a substream of art-thought running through my brain. One of the greatest joys of my life is sharing the message of Better Living through Creative Expression with others. Writing this book is my Blues Brothers moment; I'm on a mission from God. Visit my blog at paperdollpost.blogspot.com.

debbi would like to thank . . .

the four ladies who made this book possible: Pokey Bolton for coming up with the idea that Cheryl and I write a book together; Tricia Waddell for asking questions, listening to the answers, and helping us make a good book; Darlene D'Agostino for cleaning up the kitchen and putting away the dishes; and Cheryl for sending me that e-mail in December 2006. I was in dire need of a friend.

{ RESOURCE GUIDE }

ARROWMONT SCHOOL OF ARTS AND CRAFTS
556 Parkway
Gratlinburg, TN 37738
arrowmont.org
Nationally renowned center of contemporary arts and crafts education

ARTCHIX STUDIO
585 Stornoway Dr.
Victoria, BC, Canada V9C 3L1
(250) 478-5985
artchixstudio.com
Collage images, metallic paper embellishments

BASICGREY SCRAPBOOK PAPER
377 N. Marshall Way #9
Layton, UT 84041
(801) 544-1116
basicgrey.com
Scrapbooking papers and paper embellishments

BAZZILL BASICS CHIPS & CARDSTOCK
501 E. Comstock Dr.
Chandler, Arizona 85225
(480) 558-8557
bazzillbasics.com
1½" (4 cm) chipboard squares, cardstock, paper flowers

CARAN D'ACHE
Fine Arts (American Distributor)
38-52 43rd St.
Long Island City, NY 11101
(718) 482-7500
carandache.com
Water-soluble crayons

CREATIVITY, INC./DMD
7855 Hayvenhurst Ave.
Van Nuys, CA 91406
(800) 727-2727
creativitycraftsinc.com
Decoupage and collage papers

DIBONA DESIGNS
1400 Dakota Ave.
Suite 206
St. Louis Park, MN 55416
(612) 860-4086
dibonadesigns.com
Collage papers and imagery

ECLECTIC PRODUCTS
101 Dixie Mae Dr.
Pineville, LA 71360
(800) 333-9826
eclecticproducts.com
E6000 heavy-duty adhesive

EK SUCCESS
eksuccess.com
Cutter Bee scissors and other paper-crafting and scrapbooking supplies

GOLDEN ARTIST COLORS
188 Bell Rd.
New Berlin, NY 13411-9527
(800) 959-6543
goldenpaints.com
Gel and matte medium

GRAFIX
5800 Pennsylvania Ave.
Cleveland, OH 44137
(800) 447-2329
grafixarts.com
Shrink film

JUDIKINS
17803 S. Harvard Blvd.
Gardena, CA 90248
(310) 515-1115
judikins.com
Diamond Glaze dimensional adhesive

PLAID ENTERPRISES
3225 Westech Dr.
Norcross, GA 30092
(800) 842-4197
plaidonline.com
Mod Podge decoupage medium

PRIMA MARKETING
5564 Edison Ave.
Chino, CA 91710
(909) 627-5532
primamarketinginc.com
Paper flower embellishments

RANDOM ARTS
PO Box 7
Saluda, NC 28773
(828) 749-1165
randomartsnow.com
Wholey Paper

RANGER INDUSTRIES
15 Park Rd.
Tinton Falls, NJ 07724
(732) 389-3535
rangerink.com
Inks and embossing supplies

ROYALWOOD LIMITED
517 Woodville Rd.
Mansfield, Ohio 44907
(800) 526-1630
royalwoodltd.com
Waxed-linen thread

SANFORD
2707 Butterfield Rd.
Oak Brook, IL 60523
(800) 323-0749
sanfordcorp.com
Sharpie markers and other writing utensils

SHANNA LEINO
Cheshire Mills
Boarding House
PO Box 151
Harrisville, NH 03450
shannaleino.com.
Bone folders

Paper-doll pattern from page 16
Enlarge 270%

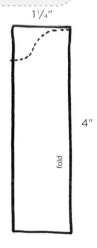

1¼"

fold

4"

Clutch pattern from page 52

small wing
for quilt

large wing
for quilt

Winged heart pattern from art quilt on page 62
Enlarge 365%

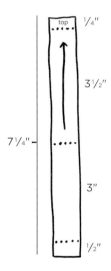

top ¼"

3½"

7¼"

3"

½"

Spine pattern from fabric journal on page 70

roof—cut one L, one R

chimney
cut one

House pattern from fabric journal on page 70
Enlarge 325%

Cottage-card pattern from page 110
Enlarge 355%